SACRED MIRRORS

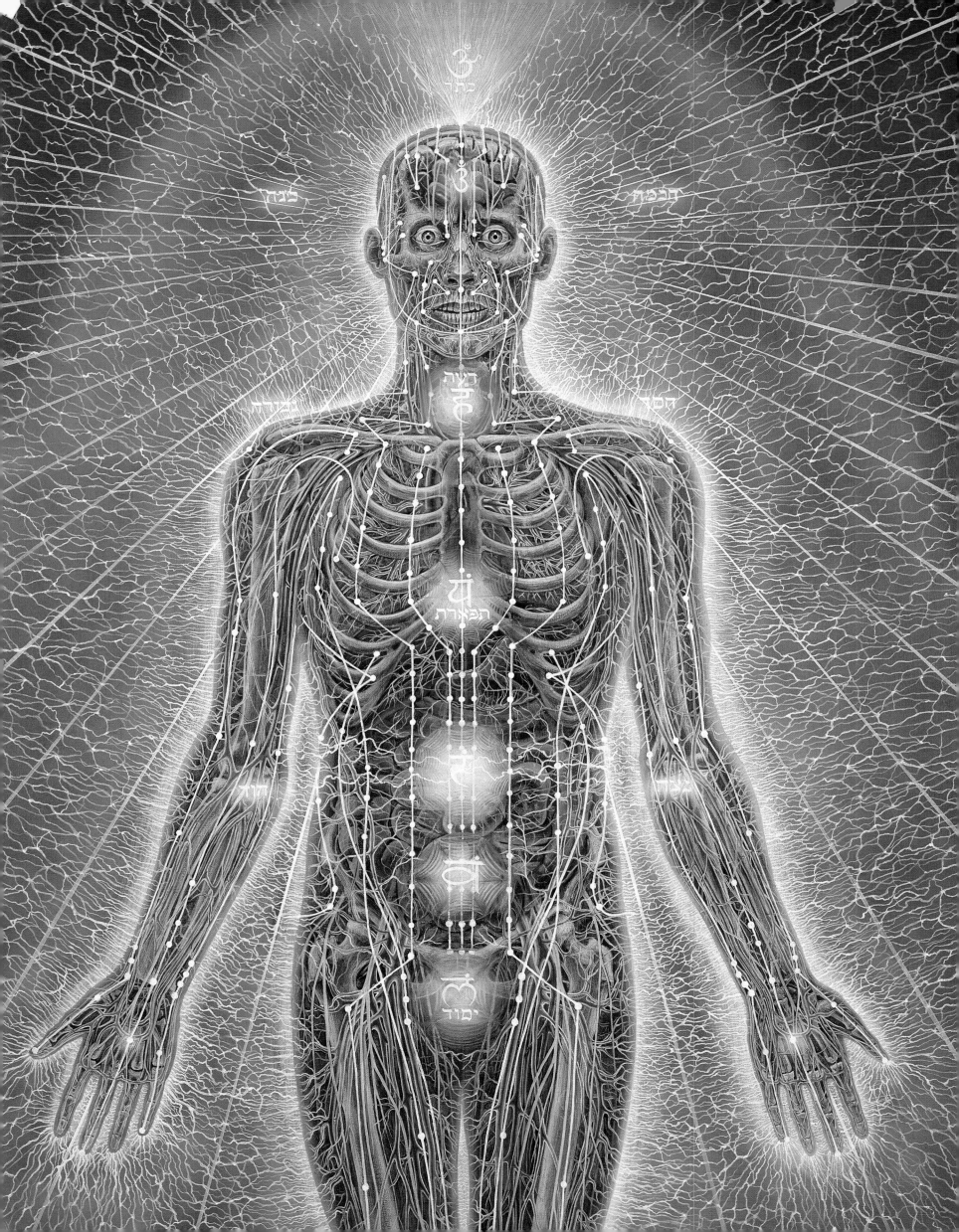

SACRED MIRRORS

THE VISIONARY ART OF ALEX GREY

with essays by

KEN WILBER • CARLO McCORMICK • ALEX GREY

INNER TRADITIONS INTERNATIONAL
ROCHESTER, VERMONT

Inner Traditions International
One Park Street
Rochester, Vermont 05767
www.InnerTraditions.com

LIBRARY OF CONGRESS CATALOGING-IN-PUBLICATION DATA
Grey, Alex.
The sacred mirrors : the visionary art of Alex Grey / with essays by
Ken Wilber, Carlo McCormick, Alex Grey
p. cm.
ISBN 0-89281-257-5
ISBN 0-89281-314-8 pbk.
1. Grey, Alex—Philosophy. 2. Grey, Alex—Criticism and
interpretation. I. Wilber, Ken. II. McCormick, Carlo. III. Title.
N6537.G718S23 1990
759.13—dc20 90-4773
 CIP

Design by Alex Grey, Susan Davidson, and Frank Olinsky

Acknowledgment and credit are due to the following photographers:
David Carbone: *Living Cross;* James Dee: *Sophia; Pregnancy; Nursing; Gaia; Journey
of the Wounded Healer; Dying;* Alex Grey: *Praying; Kissing; Deities and Demons;
Prayer Wheel;* Will Howcraft: *New Family; Copulating;* Kedl Photography: *Psychic
Energy System; Spiritual Energy System; Universal Mind Lattice; Void/Clear Light;
Avalokitesvara; Christ; Spiritual World; Sacred Mirrors* frame; Adrian Paul: *Material
World; Skeletal System; Nervous System; Cardiovascular System; Lymphatic System;
Viscera; Muscle System; Caucasian Woman; Caucasian Man; African Woman; African
Man; Asian Woman; Asian Man; Holy Fire; Theologue;* John Roth: *Sacred Mirrors*
frame (detail); Dan Soper: *Body, Mind, Spirit.*

Frontispiece: *Psychic Energy System* (detail), 1980, acrylic on linen

Printed and bound in China

20 19 18 17 16 15 14

Portions of the proceeds from the sale of *Sacred Mirrors* are donated to the *Chapel
of Sacred Mirrors,* a 501(c)(3) nonprofit organization. The *Chapel of Sacred Mirrors*
will provide a permanent public exhibition of Alex Grey's most outstanding and
widely appreciated works of transformative art, fostering a vision of the fully
awakened human potential. For further information please visit
www.sacredmirrors.org

CONTENTS

ACKNOWLEDGMENTS 6

PREFACE 7

IN THE EYE OF THE ARTIST: 9
Art and the Perennial Philosophy
Ken Wilber

THROUGH DARKNESS TO LIGHT: 17
The Art Path of Alex Grey
Carlo McCormick

THE SACRED MIRRORS 31
Alex Grey

SACRED MIRRORS—THE PLATES 39

PROGRESS OF THE SOUL 71

ENDNOTES 96

ACKNOWLEDGMENTS

I would like to thank the Marshall Frankel Foundation and Liz and Becky Frankel for their generous support of the *Sacred Mirrors* book project. Marshall Frankel, a Chicago businessman and well-known art collector, expressed a great interest in the *Sacred Mirrors* during his life, and it was a pleasure to have been his friend. I greatly cherish the friendship of his daughters.

Thanks to publisher Ehud Sperling and the Inner Traditions staff for believing in and actualizing the *Sacred Mirrors* book project. Leslie Colket and Wendy Tilghman have edited the text with great skill and insight. Susan Davidson and Frank Olinsky provided invaluable design work. Thanks also to art director Estella Arias for cover consultation and press approval.

Great appreciation is due my friend Ken Wilber, for giving us his insightful perspective on the spiritual in art and for selflessly providing his essay in the shadow of a time of personal grief, after the death of his beloved and extraordinary wife, Treya.

Special thanks go to Carlo McCormick, who is always deluged with requests for essays and written work. He took on the difficult task of researching all of my past work in depth and has given me with his essay the immense satisfaction of being understood.

Thanks to the assistance of my late grandmother, Carrie Stewart, who believed in my work, I was able to begin the project of creating a book about the *Sacred Mirrors*. Thanks also to my parents and to Allyson's family for their continual emotional and moral support, and for remaining the healthy source of our experience of parenthood. Thanks to our daughter, Zena, for her pure smile and inspirational joy. She gives us back much more than we could ever give to her.

There is no one I must thank more than my greatest and most intrepid friend, my wife, Allyson, who has been inspiring and helpful throughout the *Sacred Mirrors* project. We sculpted and cast the frames together, a labor of love and a most grueling task. She has edited my written words and advised me in almost every aspect of my work. I consider her a great artist and feel privileged to collaborate with her. This book is dedicated to Allyson.

PREFACE

On June 3, 1976, we simultaneously shared the same psychedelic vision: an experience of the "Universal Mind Lattice." Our shared consciousness, no longer identified with or limited by our physical bodies, was moving at tremendous speed through an inner universe of fantastic chains of imagery, infinitely multiplying in parallel mirrors. At a superorgasmic pitch of speed and bliss, we became individual fountains and drains of Light, interlocked with an infinite omnidirectional network of fountains and drains composed of and circulating a brilliant iridescent love energy. We were the Light, and the Light was God.

It seemed as if the "real" material world was an illusory veil, now withdrawn, and the energetic scaffolding of causation and creation, the Ultimate Reality, eternal and infinite, was laid bare before and through us. All polarities were incorporated and transcended without conflict—past and future, microscopic and cosmic, male and female, self and other. Yet there was no extinguishment of awareness. Indeed, we each felt this state to be our purified essence. "I" was one particular point in the vast network, aware of "my" unique relationship with all points in the field. An infinite Void seemed to provide the ground from which this lattice of light emerged. We both realized our vital connection with all beings and things in the Universe, with God. We felt that death was not to be feared because the Light was our spiritual core and we would eventually return to the profoundly transcendent bliss of this lattice realm.

Sensing that we shared the same transpersonal realm at the same time, we didn't confirm it until we had both returned from the experience. It was one of the most puzzling and extraordinary events in our lives. Afterwards, we described the lattice and drew pictures that depicted for each other the same space. The visible and invisible universe became our family. We were no longer separate, but part of a mysterious web of energy that connected body, mind, and spirit. We were so convinced that the space was real, we felt that other people must have experienced it too. Alex found numerous accounts of it in psychedelic visions, near death experiences, clairvoyant images of Heaven Worlds, and descriptions from traditional mystical literature.

Psychologist Abraham Maslow has stated that there is a biological need for transcendence in human beings, and that the transcendent experience has a healing force. After the experience of the Universal Mind Lattice, we decided that a vision of sacred interconnectedness was the most important subject of art. This book is a result of that decision.

Over the years, Alex has exhibited and presented his work to a wide audience; invariably people tell him that certain paintings remind them of transcendent experiences they have had. Like those who have sent Alex letters requesting copies of his paintings, these are "our people." We have a spiritual bond with them. This book is for them, and for those who discover their lives to be a transformative path, who recognize a spiritual framework behind and interlacing the veil of the material world.

Allyson and Alex Grey

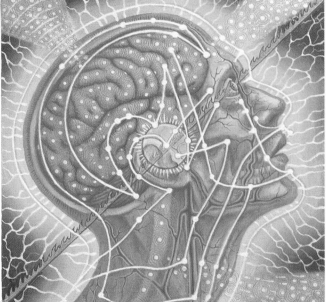

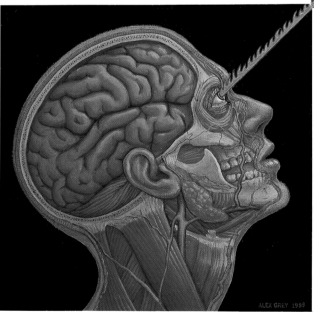

ALEX GREY 1989

IN THE EYE OF THE ARTIST:

Art and the Perennial Philosophy

Ken Wilber

According to the perennial philosophy—the common mystical core of the world's great spiritual traditions—men and women possess at least three different modes of knowing: the eye of flesh, which discloses the material, concrete, and sensual world; the eye of mind, which discloses the symbolic, conceptual, and linguistic world; and the eye of contemplation, which discloses the spiritual, transcendental, and transpersonal world. These are not three different worlds, but three different aspects of our one world, disclosed by different modes of knowing and perceiving.

Moreover, these three modes of knowing, these three "eyes," are not simply given to a person all at once. Rather, they unfold in a developmental sequence from the lower to the higher. In the first two years of a baby's life, sensorimotor intelligence—the eye of flesh—develops and evolves to disclose a material world of "object permanence," of solid surfaces and colors and objects, as well as the sensorimotor body's own feelings and emerging impulses. In the following decade or two, the eye of mind will increasingly emerge and develop, disclosing in its turn the world of ideas, symbols, concepts, images, values, meanings, and intentions. If development continues beyond the mind via meditative disciplines or, in some instances, psychedelically induced mystical experience—then the eye of contemplation opens and discloses the world of soul and spirit, of subtle energies and insights, of radical intuition and transcendental illumination.

The eye of flesh tends to disclose a prepersonal, preverbal, preconceptual world, a world of matter and bodies. The eye of mind tends to disclose a personal, verbal, and conceptual world, a world of ego and mind. And the eye of contemplation tends to disclose a transpersonal, transverbal, trans-egoic world, a world of luminous soul and spirit. The first realm made visible to the eyes of perception is composed of *sensibilia*, or phenomena that can be perceived by the body. The second realm is composed of *intelligibilia*, or objects perceived by the mind. The third realm consists of *transcendelia*, or objects perceived by the soul and spirit. These three overall realms, from matter/body to ego/mind to soul/spirit, are collectively referred to in various contemplative traditions as the Great Chain of Being.[1]

When it comes to a critical theory of art based on the perennial philosophy then, the immediate question is: What eye, or eyes, is the particular artist using? Of course, the artist's medium is usually sensibilia, or various material sub-

stances (paint, clay, concrete, metal, wood, etc.) The critical question, however, is this: Using the medium of sensibilia, is the artist trying to represent, depict, or evoke the realm of sensibilia itself, or the realm of intelligibilia, or the realm of transcendelia? In other words, to the standard question, "How competent is the artist in depicting or evoking a particular phenomenon?", we add the crucial ontological question: "Where on the Great Chain of Being is the phenomenon the artist is attempting to depict, evoke, or express?"

We have, then, two important but different scales of critical evaluation for any work of art: 1) How well does it succeed on its own level? 2) How high is that level?

The great achievement of European art in the last thousand years was the convincing depiction of the realm of sensibilia. Not much more than 500 years ago the rules of perspective became widely known and utilized in painting, embodying a discovery and an understanding of the actual geometry of the material-sensible world (as in, for example, Renaissance art.) Painting became increasingly *realistic,* or empirical, tied to the concrete sensory world; the eye of flesh and its bodily perspective. Even religious art tended to be concrete and literal. Depictions of the Virgin Birth, the Ascension, the parting of the Red Sea—all were portrayed as actual, concrete facts, not as symbolic, figurative, or conceptual. In other words, even most "religious" art was tied to the realm of concrete sensibilia.

All of that would begin to change with the coming of modern art. If the first great achievement of European art was to perfect the depiction of sensibilia, the second great achievement was to rise above it and begin to depict the various realms and aspects of intelligibilia, of symbolic and abstract and conceptual and phenomenological art and its rules. The media would still be sensibilia, but the depicted object no longer would be bound by the rules or perspectives of matter; it would not follow the contours of matter, but of mind. No longer Nature, but Psyche. No longer realistic, but abstract. Not things, but thoughts. Not Euclidean, but Surrealistic. Not representational, but impressionistic or expressionistic. Not literal and concrete, but figurative and symbolic.

Starting with Paul Cezanne, whom Matisse called "the master of us all," we see the fixed perspectivism of the material-sensible world broken down and superseded by an emotional-psychological participation (intelligibilia), not mere representation (sensibilia.) With Kandinsky, arguably the father of abstract art, we see the full emergence, if not perfection, of intelligibilia over sensibilia; of the condensed potency of the abstract over the mere imitation of Nature's forms. As Kandinsky put it, "It must become possible to hear the whole world as it is without representational interpretation."[2] That is seeing not with the eye of flesh, but with the eye of mind.

Cubism began as a type of geometry of natural form, but quickly became a vehicle for essential impressionism, an act of attention not just to outer objects but also to inward mental forms and patterns. "This is the art of painting new structures out of elements borrowed not from the reality of sight, but from the reality of insight,"[3] as one critic expressed it.

Perhaps no one articulated the need to go from mere Nature to more than Nature better than Piet Mondrian. "As the natural becomes more and more 'automatic', we see life's interest fixed more and more on the inward. The life of *truly modern* man is directed neither toward the material for its own sake nor toward the predominantly emotional [matter/body]: rather, it takes the form of the autonomous life of the human [psyche] becoming conscious. . . . Life is becoming more and more *abstract.* The truly modern artist *consciously* perceives the abstractness of the emotion of beauty. . . . In the *vital reality of the abstract,* the new man has transcended the feelings of nostalgia. . . . There

is no escaping the tragic, so long as our vision of nature is naturalistic [tied to sensibilia]. That is why a deeper vision is essential."[4] Deeper than sensibilia is intelligibilia, and deeper still, is transcendelia. Mondrian and Kandinsky were pioneers in both.

The point was to free the mind from the confines of nature, and thus to free art from photographic realism, while at the same time plumbing the depths of the psyche and giving artistic expression to that extraordinary search.

The art of the mind, of depicting the geometries of thought and the patterns of psyches, the art of intelligibilia clothed in sensibilia, was found in an inward, not solely outward, direction. It was an act of attention to the inner subject as well as to the outer object, and conveyed the interrelationship between the two. In it, the patterns of thought interrelated with the patterns of things. Although these patterns or essences depend in part on looking inwardly with the mind's eye, they are not merely subjective or idiosyncratic, but rather, to the extent that they resonate truly in a work of art, reflect the larger patterns of reality itself. As Brancusi almost screamed out: "They are imbeciles who call my work abstract; that which they call abstract is the most realist, because what is real is not the exterior form but the idea, the essence of things."[5] As Hegel and Schelling would put it, "The ideal is real, and the real is ideal."

By exploring the realm of intelligibilia, modern artists were able to return to the ground of sensibilia with new insights and radically novel approaches. The Cubists brought a completely new understanding to form, while Seurat, Delaunay, and Matisse brought a new revelation of color. Matisse, for example, freed color from the constraints of nature. As he forcefully put it, "The Beaux-Arts masters told their students: 'Copy nature stupidly.' Throughout my entire career I have reacted against this attitude. . . . Color exists in itself, possesses its own beauty. . . . I understood then that one could work with expressive colors which are not necessarily descriptive colors."[6] Color could be expressive of intelligibilia, not just descriptive of sensibilia.

The point, then, was to stay firmly rooted in sensibilia—not to deny nature or repress it; but to reach through or beyond sensibilia to intelligibilia, to the essence of mind, idea, and intention, and to clothe them in the "plastic" of the material or natural realm; and further, through introspection and intuition of the patterns of mind and intelligibilia, to return afresh with new and radical insights into the form and color and essence of sensibilia itself.

We now reach the third and most crucial evolutionary movement: the emergence in art not just of body or of mind, but moreover of spirit, and the correlative depiction in art not just of sensibilia and intelligibilia, but also of transcendelia.

Not that the spiritual hadn't been portrayed before in art, but in the West its flowering had always been fragile. Early Christian icons, with their simplified forms floating on golden fields of "light," were sacred symbols of the incarnation of the Word. When Christianity adopted the figurative, naturalistic style of secular art, it replaced the symbolic icon with a fundamentalist form of realism that specialized in the literal depiction of spiritual events such as the resurrection. There is nothing transcendental in fundamentalist "facts" that wish to claim the dubious status of empirical sensibilia.

Contrary to prevailing tendencies of realism in European art, there has been a sporadic Western "tradition" of mystical and visionary painting over the last 900 years. Early evidence of this visionary symbolist art can be found in the twelfth century in the work of Hildegard of Bingen. She was a powerful abbess who created a major text explaining the symbols of her visions and had the visions illustrated or illuminated. These somewhat crude but beautiful works are forms of transcendelia.

Michelangelo, a neo-Platonist, was trying to symbolically express through his art a spiritual ideal clothed in material form. In addition he said, ". . . it is not sufficient merely to be a great master in painting and very wise, but I think that it is necessary for the painter to be very moral in his mode of life, or even, if such were possible, a saint, so that the Holy Spirit may inspire his intellect.[7]"

Hieronymous Bosch created a unique world of highly symbolic, imaginative vistas of heavens and hells intended to reinforce the spiritual faith of his viewers. The poet and visionary artist William Blake wrote in the *Marriage of Heaven and Hell:*

> If the doors of perception were cleansed every thing
> would appear to man as it is, infinite.
> For man has closed himself up, till he sees all things through
> narrow chinks of his cavern.[8]

To Blake, painting had nothing to do with copying from nature, but was an art of divine imagination:

> Shall Painting be confined to the sordid drudgery of fac-simile representations of merely mortal and perishing substances, and not be as poetry and music are, elevated into its own proper sphere of invention and visionary conception? No, it shall not be so! Painting, as well as poetry and music, exists and exults in immortal thoughts.[9]

The nineteenth-century symbolist painter Delville wrote that he intended to evoke, " . . . the great universal life . . . which rules and moves the universe, beings and things, mortals or immortals, in the infinite rhythm of Eternity."[10] And in the twentieth century the painter Pavel Tchelitchew's works moved through the visionary, symbolic levels of consciousness to mystical abstractions reflecting deep transcendental levels of being and light.

There were also artists throughout the history of European art who depicted images of sensibilia but, like the Zen landscapists, reached a state of contemplative absorption which dissolved the boundary between subject and object and opened a channel to immanent transcendelia. The pre-renaissance master, Fra Angelico, was a monk and a painter. His works were intended for the contemplation of other monks and are filled with a devotional intensity which raises them high on the Great Chain of Being. Rembrandt was good at creating the illusion of space in his painting, but he was *great* precisely because he also revealed a dimension of the human soul. He revealed character and a living, spiritual presence in all his portraits and the self portraits in particular. The spirit in the flesh, this is what we see—not a mound of material sensibilia, but a soul timelessly peering through matter. Van Gogh let the rhythms of the cosmos, a universal energy, resonate through his works. His landscapes are saturated with spirit. In the twentieth century, Ivan Albright has conveyed in his magical hyperrealist paintings a sense of the awesome and infinite dimension of the immanent divine. These artists had powers of concentration, imagination, or mystic reverie that gave them glimpses of divinity and enabled them to create visionary or representational images that evoke a world beyond sensibilia and intelligibilia. Many of the pioneers in modern abstraction, such as Kandinsky, Mondrian, Malevich, Klee, and Brancusi felt that a new spirituality in art would have to be Spirit approached directly and immediately, not in the mythic forms of the religious mind or with representational imagery, but through direct intuition and contemplative realization. They felt that they had in fact pushed

beyond the individual mind and body and discovered, through their art, a genuine and powerful approach to Spirit itself. They were disclosing and portraying not just sensibilia, or intelligibilia, but transcendelia.

Art was to be not just the technical skills of observation and execution, or creativity, but a method of spiritual growth and development on the part of the artists. True art, according to Kandinsky, must involve the cultivation of the soul and spirit: "The artist must train not only his eye but also his soul, so that it can weigh colors in its own scale and thus become a determinant in artistic creation."[11]

If artists are to "be the servants of Spirit," he said, then they must grow and develop their own souls to a point at which they are capable of directly intuiting the spiritual dimension. In order to see (let alone artistically convey) Spirit, the eye of contemplation must first be opened, and this opening—Kandinsky's "revelation of Spirit illumined as if by a flash of lightning"[12]—discloses newer, higher, and wider dimensions of existence.

In the artist's own spiritual growth and development, ever subtler experiences, emotions, and perceptions would come into view, and it was the artist's duty to portray these subtler experiences (transcendelia), and thus to evoke them and encourage them in those who witness with care the finished work.

We have said that sensibilia is the realm of the prepersonal, intelligibilia the realm of the personal, and transcendelia the realm of the transpersonal. That is, the body and nature are preverbal, preconceptual, and therefore pre-egoic and prepersonal. The mind is verbal, conceptual, and symbolic, and therefore forms the basis of ego and individuality. But Spirit, being universal, is beyond body and mind—it is transverbal, trans-egoic, transindividual. It exists at a point where the soul touches eternity and completely transcends the prison of its own involvement.

The more consciousness evolves, the more it grows beyond the narrow bounds of the personal ego, the more it touches the transpersonal and universal Divine. Thus it is no accident that Mondrian states: "All art is more or less direct aesthetic expression of the universal. This *more or less* implies degrees [of development of evolution]. . . . A great heightening of subjectivity is taking place in man—in other words a *growing, expanding consciousness*. Subjectivity ceases to exist only when the mutation-like leap is made from individual existence to universal existence." Thus, he concludes, "The new culture will be that of the mature individual; once matured, the individual will be open to the universal and will tend more and more to unite with it"[13]—a common conclusion of mystics the world over.

According to modern masters such as Malevich, Franz Marc, Paul Klee, Brancusi, and others, true and genuine art, the highest art, involved: First, the development or growth of the artist's own soul, right up to the point of union with universal Spirit and transcendence of the separate self or individual ego; and second, the artistic depiction/expression of this spiritual dimension, particularly in such a way as to evoke similar spiritual insights on the part of observers.

There remains the difficult question: Did these great modern masters succeed? Did they succeed, not only in freeing intelligibilia from sensibilia, but also in freeing transcendelia itself and bringing it down into "plastic form"? Did they discover and portray not just body-nature and psyche-mind, but also Spirit?

My own conclusion is that, at best, the pioneering effort has just begun. I think the clear and definite accomplishment of these masters was to free intelligibilia from the confines of sensibilia, to save mind from engulfment in matter. A flash of lightning, yes; a new dawn, no. But a beginning has been made, and a powerful new direction for a future spiritual art has been charted. A genuine

search has begun for what Franz Marc called "symbols that belong on the altars of a future spiritual religion."[14]

If, as many modernists thought, true art is the manifestation of Spirit, and if Spirit is seen most clearly with the eye of contemplation, and if meditation is one of the surest ways to open the contemplative eye, it follows that the truest and purest art will be contemplative art, art born in fire of spiritual epiphany and fanned by meditative awareness.

This, of course, is precisely the idea behind many of the great Asian works of art, from Tibetan thangkas to Zen landscapes to Hindu iconography. The best of these works of art stem directly from the meditative mind. The artist/master enters meditative *samadhi,* or contemplative union, and from the union of the subject and the object, the "subject" then "paints" the "object," although all three—painter, painting, and object—are now one indivisible act ("He who cannot become an object cannot paint that object".)[15] Precisely because the painting is executed in this nondual state of subject/object union or transcendence, it is spiritual in the deepest sense. It springs from the dimension of nondual and universal Spirit, which transcends (and thus unites) both subject and object, self and other, inner and outer. These art works serve one main purpose: they are supports for contemplation. By gazing on the artwork, the viewer is invited to enter the same meditative and spiritual state that produced it. That is, the viewer is invited to experience nonduality, the union of the subject with all objects and the discovery of universal or transcendental awareness, in an immediate, simple, and direct fashion. This is the purest reason why one views art in the first place; *art created in this nondual awareness offers direct access to nondual Spirit.*

The secret of all genuinely spiritual works of art is that they issue from nondual or unity consciousness, no matter what "objects" they portray. A painting does not have to depict crosses and Buddhas to be spiritual. This is why, for example, Zen landscapes are so profoundly sacred in their texture, even if they are "just landscapes." They issue from a nondual awareness or unity consciousness, which is itself Spirit. At the height of transcendence, Spirit is also purely immanent and all-pervading, present equally and totally in each and every object, whether of matter, body, mind, or soul. The artwork, of no matter what the object, becomes transparent to the Divine, and is a direct expression of Spirit.

The viewer momentarily *becomes* the art and is for that moment released from the alienation that is ego. Great spiritual art dissolves ego into nondual consciousness, and is to that extent experienced as an epiphany; a revelation, release or liberation from the tyranny of the separate-self sense. To the extent that a work can usher one into the nondual, then it is spiritual or universal, no matter whether it depicts bugs or Buddhas.

A critical theory of art based on the perennial philosophy would demand at least two scales. On the horizontal scale would be included all the elements on a given level that influence a work of art. These elements include everything from the artist's talent and background, socioeconomic facts and psychological factors, to cultural influences. The vertical scale, according to the perennial philosophy, cuts at right angles to all these earthly facts and deals with the ontological dimension of Being itself. This vertical scale would have several components summarized by the question, How high up on the Great Chain of Being is the work itself situated?

The great artists of the modern era kept alive the quest for the sacred and the search for Spirit, while all about them the cultural world was succumbing to scientific materialism. For this we are forever in their debt. The next great movement in Western art is waiting to be born. It will not be of the body, or

the mind, but of the soul and spirit. Thus we await with much anticipation the great artistic symbols "that belong on the altars of some future spiritual religion."[16]

So I write this essay for my long-time friend Alex Grey, who is attempting to unite in his art the realms of sensibilia, intelligibilia, and transcendelia. His *Sacred Mirrors* series takes the viewer from the gross physical plane of the body, through the subtler etheric-mental-psychic planes of one's being, to the spiritual-transcendental Clear Light Void at the core of every being. Like the best of Alex's work, this series helps the self become transparent to itself, thus facilitating transcendence.

Alex has inherited the modern masters' desire to manifest a spiritual essence through art. However, his own historical and stylistic roots emerge more from a metaphysical visionary tradition which can be traced back through Blake and Fludd to nineteenth-century symbolists like Delville and Klimt, and artists in this century such as Tchelitchew and Fuchs.

These visionary artists shared similar spiritual intentions with the early modernists, but sought to merge the immanent (representational) aspects of the Divine with the transcendental (abstract/non-representational) aspects. Alex's work is a rich amalgam that includes references to ancient Hindu and Tibetan Buddhist sources as well as contemporary scientific and medical illustration. The detailed precision of his work arises from an obsession to experience and communicate the multidimensional nature of the self and the transformative and evolutionary potential of consciousness.

Alex's work places him in a very small group of important contemporary artists; through his art he aspires to all three realms—reaching from matter, to mind, to spirit—in itself a very rare ideal.

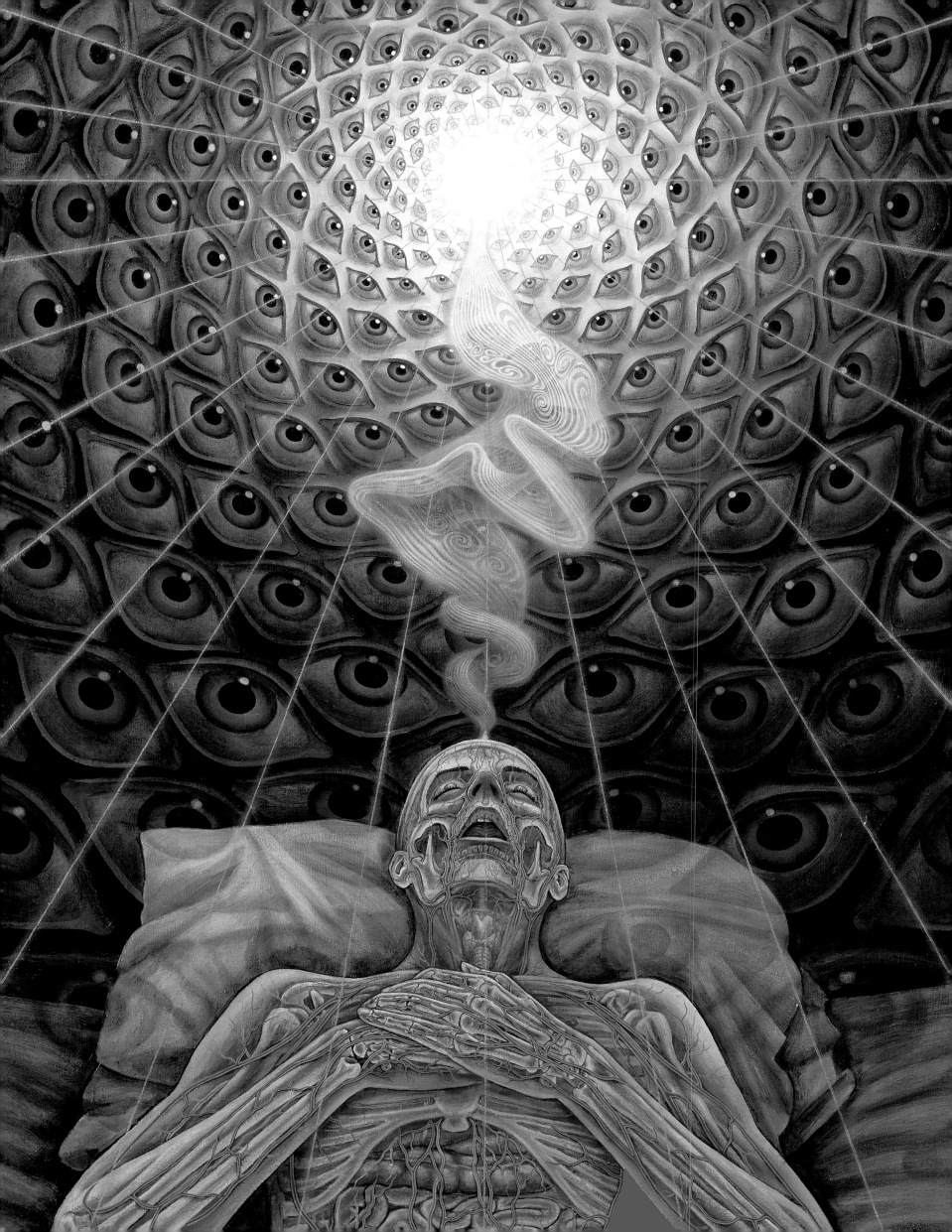

THROUGH DARKNESS TO LIGHT:

The Art Path of Alex Grey

Carlo McCormick

As we near some sense of finality in our cultural imagination—approaching the millennium—it is easy to sense the widespread nihilist belief that we have nothing left to say. It is a time when authenticity, originality, individuality, and meaning are being questioned as aesthetic values and modalities of expression in the arts. In this current cultural climate of post-modern self-doubt, Alex Grey's work offers a rare and affirmative vision of the transcendent potential of the human spirit.

Created over a period of approximately ten years beginning in 1979 and still being modified as late as 1989, the *Sacred Mirrors* are the quintessential artistic expression of Alex Grey's cosmological view of the body, the mind, and the spirit. They are a culmination and a leaping off point for his thoughts, feelings, strategies, and activities as an artist. Since 1973 Grey had been doing ritualistic performance art. At the beginning of the *Sacred Mirrors* project Grey came to terms with certain emotional ambiguities and intellectual questions that had troubled him in his life and art-making since early adolescence. The *Sacred Mirrors* brought him back to a tradition of painting that his early performance pieces had deliberately rejected. In the *Mirrors*, we can see the emergence of a style and content, a bio-energized spiritual anatomy, that has predominated nearly all of his painting since then.

The *Sacred Mirrors* are a kind of personal apotheosis in Grey's art—a culmination of many years of visual and metaphysical investigation. There is an unqualified intensity to these pieces, not only in terms of the extensive labor and superior craftsmanship evident in them; but more significantly, in the thought and feeling behind them. For this latter distinction we must come to regard them on high ground, and dig deeper into the imaginative and daring work that preceded them. Therefore a discussion of the work prior to and following this singularly massive set of images will provide a matrix in which to hang these heavy paintings, one that is by nature sturdier and more compelling than the sterile, perfect, white walls of their usual art-world presentation.

The art that came before the *Sacred Mirrors* represents a bizarre and necessary journey for the artist. Starting with the most anti-traditional of forms—performance art—Grey's explorations culminated in the most traditional of forms—painting. Performance art was the tool and the symbol of his inner search into the essential material and spiritual questions: What is life? and What

is death? His investigations raise exceedingly ugly and taboo issues in our moral, ethical, and aesthetic philosophical value systems. However, these are the threads that led to the creation of the *Sacred Mirrors*. To come to terms with the morbid elements haunting this work, I would offer the following vantage point: Alex Grey must be considered as a shaman, a mysterious healer of the tainted collective soul and the dark times in which our hypertechnological, anatomically, and spiritually alienated culture currently resides.

His work may be read as an elaborate psychic ordeal schizophrenically split between efforts to exorcise from the social body its embedded and disguised regions of illness through his own personal pain and degradation, and efforts to seek, as the shaman does, the cyclical path toward rebirth and renewal through profane forays into the realms of demonic possession, absurdity, and ultimately into the savage abyss of death. Comparing Grey's performance work to the shaman's path, we thus reach for the most appropriate analogue by which this work may be understood.[1]

Self-portrait—age 16

Magician, priest, and healer, the shaman is feared and revered in the cultures where he or she practices. A shaman is one who embarks on a path that challenges the norms of society—its values, imagery, and sacred cows—in order to achieve the healing powers and wisdom that are its goals. He or she stands in opposition to society's highly developed, mutually agreed upon perception of reality that forms the collective dream of sleepwalking humanity.

Transculturally, the shamanic process involves an initiatory phase in which the shaman meets his/her animal allies and descends to the underworld. After confronting death in some dramatic event he/she is "reborn" and ascends to the higher worlds to meet helpful spirits. Along the way the shaman receives his or her healing powers and visions.

The shaman's path can be understood in terms of a passage through the negative, demonic side of reality—a tradition embraced by mystical cultures as well. In Hinduism there is the cult worship of Kali, the mother of time and black goddess of death, who is sometimes portrayed copulating with the corpse of Shiva. Worship of certain horrifying Tibetan Buddhist deities invokes terror and awe in the devotee who goes through an annihilation of self to be identified with the deity.

Along with an ability to contact the spirit world, psychedelic drugs, intoxication, sex, nudity, physical abuse, and self denigration are all frequently part of the way of the shaman. Those who take a shaman's path become either lost in a maze of self-delusion or, if they are among the few survivors, they are freed of the yoke of mediocrity and opened to a vision of the Origin—the source of all things. Thus freed, the shaman returns to serve the community by journeying between the lower, middle, and upper worlds.

Self-portrait—age 17

Like the paths of shamans and mystical travelers, the arduous route Grey took to spiritual transcendence, purification, and the liberating vision that became the *Sacred Mirrors* was not one of simple god-like purity, but a painful, errant, and circuitous journey through poisonous swamps and jungles buried deep within the blackest, bleakest recesses of life, death, ritual, and perception. The pitfalls on this shadowy, earthy road were sink-holes into the abyss of madness and malevolence, but the light at the end of the tunnel was that of the Godhead itself.

ADOLESCENT PICTURES

Grey's father was a professional graphic artist, and with his assistance Alex started learning how to draw at an early age. Young Grey exhibited a precocious talent. Two interesting but immature self-portraits he made at the ages of sixteen and seventeen merit attention not as paradigms of the visionary comprehension he later found in his *Sacred Mirrors*, but as the first gateways of self-awareness

he had to pass through on the way to his ultimate out-of-the-body entry into the vast spiritual cosmology beyond. With their own bold and beautiful leaps of imaginative fancy, they are characteristic, in an intuitive and impressionable way, I suppose, of the psychedelic era in which they were produced. The self-portrait from age sixteen anticipates an unfocused expression of Grey's inner wrestling (left hand wrestling with praying hands), and his preoccupation with the life cycle: Grey's right hand touches the connection point between his own fetus and corpse. In the self-portrait from age seventeen we see a confrontation of polar forces as a two-headed being attempts to remove the dark, sick side of himself. In Grey's geometry of body, mind, and spirit, these paintings were already plotting his obsession with mortality and polarity. Perhaps these works are the earliest manifestations of "the call" to self-knowledge through art.

During the late sixties and seventies avant-garde art activities broke all aesthetic boundaries. Performance art was a case in point, with events such as the shamanic works of Joseph Beuys, the cathartic violence of the Viennese "Actionists," and the activities of America's foremost body artists, Vito Acconci and Chris Burden. The term "performance" did not mean that there needed to be an audience or proscenium stage in a traditional sense. Documentation in any form became the alternative way to reach an audience. Grey's first significant exploration of this medium occurred in Ohio after he finished art school.

It is easy to see that even in his less developed early pieces (despite their inherent relation to the general art trends of the day), Grey's voice was always uniquely and uncompromisingly his own. Two pieces, *Secret Dog* and *Rendered Dog,* used as their basis the corpse of a dog. With a pseudo-scientific rigor based on a distinct fascination and an impersonal and callous "objectivity" that is as rare as it is unnerving in the humanist tradition of fine arts, Grey probed into the sensitive metaphysical issues surrounding life and death and tried to work out a conception of existence based on the physical, or anatomical, facts of being.

In *Secret Dog,* Grey picked up an animal that had been recently run over, and put it in a bag near a river. Every few days, Grey photographed the remains to document its gradual decay. *Rendered Dog* was made up of two packages, displayed side by side, one of defatted meat in powder form, and one a nondescript mass of animal fat. These two bags of by-products, the result of an animal rendering process, are the two prime elements used in a variety of commercial products. *Rendered Dog* is a sculptural equation that reduces life to its most meaningless components, an immovable feast served up in hauntingly severe and depersonalized minimalist fashion. These two works were the first of many attempts Grey would make to overtake his disgust and fear of biological death and to face uncertainties about mortality that are wrapped tightly in his obsessive attraction to death. "Doing the dog pieces," Grey has stated, "made me wonder about the nature of consciousness. Life energy, consciousness, awareness seemed to be the things that were removed, and with that came the dissolving or dissolution of the body. It was a meditation on impermanence. If you're really gone, where do you go? And if you don't go anywhere, what does that say about the nature of the universe in which you live? Is it just a material world?"

"There was also the reference to the times, the feeling pre-Watergate, of a general sickness, of secrets rotting away inside us, secrets eating away at the soul of America. This rotting dog was like a festering inside the government, inside people. The stench could have been the stench of a dead god (I was reading Nietzsche at the time), the stench of the rotting bureaucracy of our rotting government. It could have been Vietnam. In effect it was symbolic of a

psychological or a cultural state, but what was physically there was the observation of the process of death, the fact that every living being faces."

POLARITY WORKS

As early as his adolescent self-portraits, Grey's art began grasping for an understanding of the opposing forces within the self and the universe, in particular the polarity of spirit and matter, a theme also addressed in the *Sacred Mirrors*. He became consumed by the idea that the conflict of opposites was the underlying principle of the cosmos. As Jung has noted, "Just as all energy proceeds from opposition, so the psyche too possesses its inner polarity, this being the indispensable prerequisite for its aliveness. . . . Both theoretically and practically, polarity is inherent in all living things."[2] In addition, the philosophy of Taoism states that the macrocosm as well as the microcosm is constructed on the principle of complementarity expressed as Yin and Yang.

During an intense period of creativity, from the fall of 1974 to the spring of 1975, Grey formalized his insights regarding polarities through performances which explored anatomy, social environment, and ultimately, global electro-alchemy. *Private Billboard* was a billboard image of the artist, one half of his head shaved and the other with his hair long, erected on High Street in Columbus, Ohio as an unauthorized guerilla takeover of a commercial ad space there. Visually simple and straightforward, the image came to Grey in a dream. The billboard self-portrait with an extremely eccentric haircut was evidence of his feeling of unbalance within and announced his separation from the community of (so-called) normalcy.

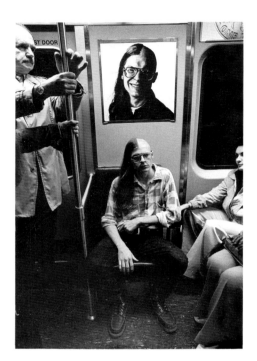

PRIVATE SUBWAY
Boston, 1974

The conceptual intent was to illustrate the hemispheric split between the two halves of the brain, the left governing the logical, reasoning functions, and the right being responsible for the intuitive, emotional processes of consciousness. That same year, Grey developed this split-brain persona further, shifting into direct social interaction. In *Private Subway* Grey appeared on a Boston subway car with his head half shaved and rode back and forth on the line for an hour and a half sitting in front of a commuter ad slot containing a photograph of himself with the same haircut. This was his first significant venture into the field of self-referential body art which was to develop into outrageous public exercises that were notably more dramatic, daring, and self-abasing.

In *Leaflets,* Grey entered a busy public square in Boston still with his polar hairdo and passed out flyers with his face pictured on them to strangers, asking each recipient to either step on the image or to be his friend and call him sometime for dinner. The direct, potentially volatile human contact evident in *Leaflets* provided an inescapably uncomfortable dialogue between the artist and his audience. Grey was thus able, by violating the protective walls of his own ego through fear, embarrassment, and a confessed emotional vulnerability, to mine his inner core of self-consciousness.

As the polarity pieces developed, Grey's shamanic method of personal realization, or what could be interpreted as a descent into madness, was greatly intensified. *Brain Sack* was a rite of passage that included shaving his head and vomiting on a human brain. By placing the symbolically charged elements of this performance into a garbage bag, the artist indicated the disposal of his negative mental condition. Like an exorcism, the piece signified the purging of mental confusion and sickness for the purpose of purification and healing.

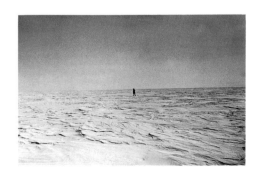

POLAR WANDERING
Resolute Bay, Canada, 1975

The culmination of Grey's polarity work came in May of 1975 with a piece called *Polar Wandering*. The performance entailed Alex's pilgrimage to the North Magnetic Pole. Grey explains, "All of the earth's magnetic lines of force converge at the North and South magnetic poles. On the polar surface of the earth this convergence creates a large magnetic field. However, this field is continually shifting, and this effect is known as polar wandering. Every few

years geomagnetic maps must be redrawn to adjust for the polar wandering effect. It seems ironic that something we rely on to get our bearings is continually moving." In that sublime minimalist landscape of frozen tundra, Grey traveled to the center of the polar region, near Resolute Bay, Canada, where the planet's magnetism is so powerful it causes the needle of a compass to spin about wildly. Once there, standing in the snow, he removed all his clothes and ran around in a circle. The action was a geophysical meditation on the rotational and electro-magnetic forces of the earth. Grey's performance induced a primal out-of-body trance state within himself, during which he experienced the sensation of slowly dissolving into a pure energy source and becoming one with our planet's innate dynamic frequency.

Grey's intensely morbid tendency as seen in the conceptual diptych of *Secret Dog/Rendered Dog* would become even more pronounced in the latter half of the seventies when he was employed as an embalmer and preparator at a morgue. It is important to stress that in his quasi-scientific work there, at times involving the dissection and dismembering of corpses, and in the extremely controversial art he made in that time, Grey's entry into socially taboo and frightening regions of activity was always fundamentally in the interest of his own private vision: the polar geometry of life and death in the matrix of personal, physical, social, and transcendental metamorphoses contained within the divine logic of mortality. Among the most provocative of the ethically debatable liberties he took during this period are *Deep Freeze*, in which he shut himself in a freezer full of corpses for five deathly silent and chilling minutes; *Life, Death, and God*, in which he suspended himself upside-down on the left side of a drawing of a crucifix tacked to the wall, while on the other side, his foot was tied in counterbalance to the foot of a dead man's hollowed-out body; and *Monsters*, a series of thirty hauntingly elegant and spiritually iconographic black and white photos of variously malformed fetuses, born dead and preserved in jars of formaldehyde.

MORTALITY CONFRONTATIONS: LIFE/DEATH POLARITY

In Buddaghosa's, *Visuddimagga, The Path of Purification*, a fifth-century summary of Buddha's teachings, there is a list of forty meditation subjects, ten of which include loathsome and decaying corpses: "a bloated corpse, a gnawed corpse, a worm-infested corpse, a hacked and scattered corpse" etc.[3] This text suggested that serious monks should visit charnel grounds as a reminder of impermanence, to confront and develop mindfulness toward their disgust and fear of dead bodies. The monks were also cautioned to maintain a distance from the bodies. Grey sought to confront his fears and act out metaphors corresponding to the dynamic balance of life and death. However, violating the sacred distance from the bodies later brought the artist to a crisis of conscience that altered his work forever and led him to create the *Sacred Mirrors*.

Grey's mortuary phase trespassed in many ways into a region we've come, for lack of a better word, to call "evil." Grey's secret research and self-expression within this forbidden zone was to abruptly cease when a series of dramatic, ego-shattering visions forced him to reevaluate his position as an artist and as a human being. Grey described them to me as follows.

HALLUCINATORY VISIONS: JUDGMENT AND ABJURATION

> In the first one, I was making love to a beautiful woman, but as she pulled me towards her, she rapidly aged and died. I saw the sides of the bed grow into a coffin that sealed me up with her. In my second dream, a brainless sage-monster hovered before me like a holographic image. Many different voices were speaking at once through this being, telling me that I wanted to be with them as much as they wanted to

be with me, and that I should join them. I felt in this creature an extremely evil presence, and I knew that I was on the edge, very near a point of no return. I started saying, over and over again, "I know divine love is the strongest power," and kept on affirming that belief until the headless figure finally faded away. A bluish light followed shortly after my banishment of the dark apparition, and from it emerged a voice who introduced himself to me as Mr. Lewis. He told me that he was an inter-planetary angel and was my guide. He reassured me not to worry. I woke up at this point. It was the middle of the night, I was covered with sweat and trembling from fear. A few days later, I had another nightmarish episode in which I found myself inside an ominously menacing courtroom, before a judge I could not see and an angry jury, as I faced a woman who accused me of trespassing her body in my morgue work. I tried to explain that I was making "art," but there was absolutely no forgiveness. The judge told me that from now on I must do more positive work, and put me on life probation never again to create such negative art.

Dream, nightmare, vision, hallucination, premonition, or mystical intervention? The fact is, on some level far outside creative reasoning or creative ferment, these events took place for Alex Grey in a way that was, to him, indisputably real. In the shamanic tradition, important information from the realm of the dead or spirits comes in visions or dream. In recalling the visions today, Grey does not so much seek to answer the question of their origin as to articulate their form in the sphere of his own soul: "If you believe in some sort of moral ecology, or karma, you could say that the entities in these visions were trying to get me on the right track. The visions were a turning point for me. They helped me to realize that I could spend a lifetime in darkness and ignorance, and that it was time for me to move on."

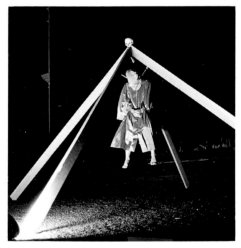

APEX
Boston, 1976

ISOLATION PIECES

Practices of ritual seclusion have been used by many shamanic and religious traditions as well as in recent scientific psychological investigations. Partial or complete sensory deprivation environments have proven to be an excellent tool for reaching the buried regions of one's mind and soul, as well as for obliterating external perceptions in order to facilitate out-of-body experiences. *Polar Wandering* was Grey's first use of these techniques.

It continued shortly thereafter in *Deep Freeze,* which was successful as an isolation piece in so far as it connected him with certain primal phobias at the core of his being. Near the end of 1976, Grey performed a two-night sensory-deprivation body-art installation called *Apex* on a rooftop in Boston, in which he vertically suspended himself with chains and a harness, inside a pyramid structure, for two uninterrupted hours on successive evenings. A sign posted for the audience to read declared the artist's intention: "During *Apex,* I will leave my body and touch you." Grey later described his experience during the performance as dissolving in a network of light, leaving his body and taking on an astral form where he was able to touch members of the audience.

In 1978 Alex and Allyson devised and began to market *The Mindfold,* a lightweight, inexpensively produced, sight and sound deprivation unit that combined a blindfold with earplugs. Grey envisioned *The Mindfold* as "a symbol of the space of self-reflective Voidness, a blank screen intended for observing the art of the mind." *The Mindfold* is still being manufactured and sold (through mail order) today, many years after Grey sold the rights. Perhaps what is most remarkable about this device is its radical conception of what constitutes the artist's role in the creation, or authorship, of another's aesthetic experience.

"I see it like I do a million other works of art," Grey said. "It's just a symbolic object or event that stimulates the viewer's individual experience." Wearing an earlier version of *The Mindfold* while using psychedelics, Alex and Allyson were able to simultaneously share an experience that forever changed the course of their art. The experience also led Alex to his metaphysical conception of the cosmological order fundamental to the *Sacred Mirrors* and the entire body of paintings Alex and Allyson have each produced in the eighties. Grey still vividly recalls his first encounters with the vision they were later to name, "the Universal Mind Lattice": "I was part of one vast luminescent, transparent lattice system of love energy. It was as if the veil of supposed 'reality' had been stripped from the material world to expose the bedrock reality, the scaffolding of the spirit. I understood it as the intricate interconnectedness of the one and the many on a level of awareness that was infinite and eternal. This was the ethical ground of compassion, where all beings and things are known to be part of us. I knew death needn't be feared because we would eventually return to the profound bliss of this realm." The effect of their psychical vision of the "Universal Mind Lattice" was immediate. From then on the Greys would be obsessively dedicated to the personal exploration and visual expression of this complex metaphysical territory.

As much as projects like *Polar Wandering, Apex,* and *The Mindfold* can be said to be appropriations in the art world context of self-induced trance, yogic, and meditational states of consciousness, so too is it possible to see in many of his performance works Grey's use of various kinds of gesture, attitude, symbolism, choreography, and staging unquestionably reminiscent of rituals found in shamanic cultures the world over. The ceremony in Grey's art is not literal "extra-cultural" transpositions, or reconstructed borrowings, but rather personal rituals with transpersonal intentions. For Grey, the purpose of the shaman's art and actions today is to catalyze the awareness or awakening within a culture to the unknown realities, or sacred mysteries, that our scientific, ecclesiastical, and civic institutions have systematically denied and suppressed since their first inception—experiences and conceptions of those hidden life forces that Grey has encountered, sincerely believes in, and is still trying to fully comprehend. With his art, either consciously or instinctively, Grey has assumed the shaman's primary role of a healer within the malignant chaos of ecocidal and biological self-destructiveness, psychological alienation, and ideologically misplaced absolutes that have diseased our beliefs and behavior in recent times. His performance pieces, as well as the *Sacred Mirrors,* provide healing meditations, either as cathartic encounters with the malady itself, or as mirroring experiences for the whole and healed aspects of our being.

Among the most visually compelling of Grey's ceremonial performance pieces was *Meditations On Mortality,* a 1980 performance at Sarah Lawrence College. Described by Grey as the imagistic culmination of his polarity work, *Meditations* began in darkness with the chanting of Tibetan monks, played on tape at a high volume. Allyson Grey entered naked, covered in white grease paint and carrying a lit candle, followed by Alex, naked and covered in black grease paint. Together they moved into the central space, a large Yin/Yang circle on the floor, surrounded by a dozen candles arranged like the hours on a clock. While Alex stared in meditation at a human skeleton seated opposite him, Allyson lit the candles, put her candle in the center of the symbol and walked clockwise around the perimeter until all the candles were burnt down and extinguished. At that point the two of them met and stepped outside of the circle, and for a brief period, accentuated by flashing strobe lights and the loud sound of horns and drums being played loudly, frantically embraced, effectively combining their

SHAMANIST RITUAL:
HEALING PERFORMANCE WORK

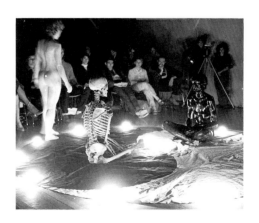

MEDITATIONS ON MORTALITY
Sarah Lawrence College
Bronxville, New York, 1980

two pigments into gray. At the return of the Tibetan chanting, Alex and Allyson resumed their original positions, and exited.

The performance was a ritual of transformation. The artists began in a sacred space as opposites or dualities, their bodies black and white, expressions of Yin and Yang. Passive and active meditations progressed to a point at which both polar opposites, the artists, responded to a new call—a strobe light flashing outside the circle of duality. Alex and Allyson stood and embraced under the light. Sensuously mixing their pigments, they created a merging of opposites. The transformation to gray symbolized the "middle way," the balance and marriage of all opposites.

In *Burnt Offering* (performed at R.A.W. in Hartford, Connecticut) Grey, covered with blood and dressed in a loincloth, presented a series of "fire sculptures" as symbols of metaphysical consciousness on the material plane. In one of these sculptures, he stood before a totem urn made of animal and human skulls. Grey read aloud passages about sacred fire from the Koran, the Bible, and the Bhagavad Gita. After reading from each, he burned the books in the urn. Then, as if the ashes contained the essence of the holy books, he rubbed them all over his body.

Since his decision to redirect his creative energy into channeling more positive life forces, Grey's interest in life/death mortality issues became less involved with the physical, visceral aspects of death and decay, and addressed itself to a vision of imminent global death. During the late seventies and early eighties, Grey produced a major body of work that confronted the ominous peril of apocalyptic oblivion and mass genocide. In this phase of heightened political and social concerns, the morbid fascination and horrific visual potency of his art now served as a humanistically relevant parable.

The Beast, created for P.S.1, the major alternative exhibition space in New York, and produced on Palm Sunday, 1982, was exceptionally elaborate and visually dynamic. As visitors entered they would slowly file past Grey, seated behind a black desk dressed as as soldier, who stamped their hands, like a passport official, with 666, the satanic number of the beast. The soundtrack played a nerve-shattering barrage of air raid sirens, nuclear bomb explosions, and Handel's *Messiah,* while on one wall the beast itself, an eight-tentacled, seven-headed spider (clutching an arsenal of guns and knives and made up of an assemblage of human skeletons and sheep's skulls) hung upon a barbed wire web spun over a red map of the world. Another wall displayed a rosy film loop projection of a hydrogen bomb blast seen from above its rising clouds. On a third wall was a massive nine and one half by ten and one half foot painting called *Nuclear Crucifixion,* depicting a Grunewald-like Christ crucified on an atomic mushroom cloud that towered above a burning city. *Nuclear Crucifixion* is one of Grey's first paintings of his psychedelic visions. The vision baffled him when it first came to him in 1976. He did not paint it until some four years later when he finally understood its meaning, interpreting it to signify that Christ stood for what is good in us, and that the same brutality and ignorance that murdered Jesus could someday be responsible for a nuclear war.

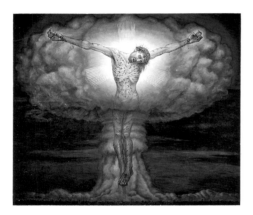

NUCLEAR CRUCIFIXION, 1980
oil on linen, 114 × 124 in.

RITUAL MORTALITY AS SPIRITUAL TRANSFORMATION

In 1983, Grey produced four major events that prefigured the spiritual metaphors of personal transcendence he would develop in the *Sacred Mirrors.* In *Prayer Wheel,* presented at the University of Massachusetts, Amherst, Alex and Allyson appeared naked, painted in gold, holding a baby doll and a knife, the artists tied together to a skeleton and to a large black cylindrical prayer wheel. The intertwined polar combinations of male and female, birth and death, was, to Grey, an externalization of the polarities of the self that keep in motion the prayer wheel as an engine of spiritual transformation. The prayer wheel bore

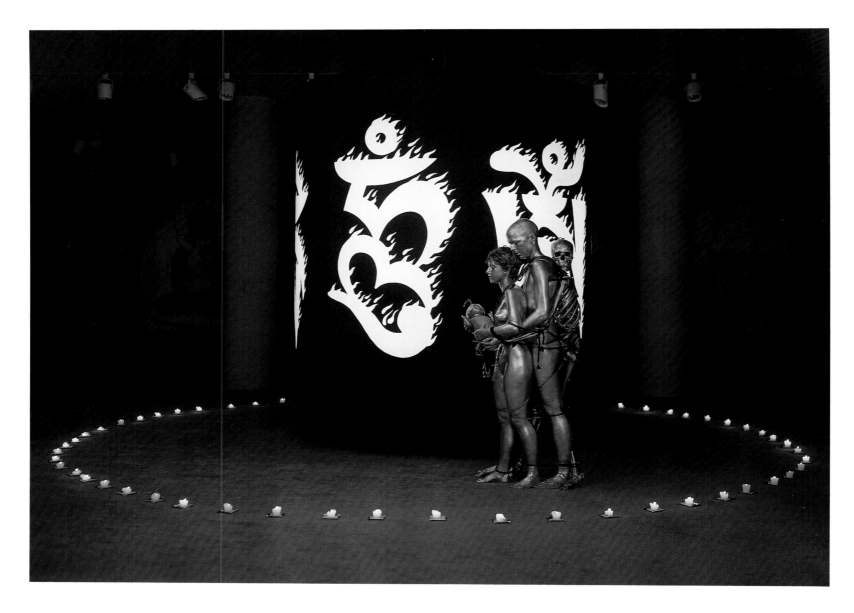

in big illuminated letters the mantra "*Om, mani padme hum,*" the prayer dedicated to Avalokitesvara. Grey included an image of *Avalokitesvara* from the *Sacred Mirror* series, seventeen of which were shown as part of the *Prayer Wheel* installation. Within a circle of candles, the Greys intoned the mantra and slowly circumambulated the prayer wheel in walking meditation for a period of an hour and a half before finally cutting the rope connecting them to the wheel and exiting the room.

Living Cross, a three-hour performance/installation produced at the Randolph Street Gallery in Chicago was a visually stunning environmental still life with the look and feel of a devotional shrine. Alex and Allyson lay naked with red votive candles on their chests in the center of a massive living cross made up of row after row of roses and apples. The perimeter was lined with candles. Above the Greys hung an angel of death—a flying winged skeleton holding in its outstretched arms a neon light in the shape of an infinity symbol. The sensual and spiritual atmosphere of the piece was enhanced by a soundtrack of Gregorian chants.

In 1989, the Greys were commissioned by Lincoln Center Out-of-Doors and Creative Time of New York to produce *Goddess*, a day-long performance/installation on the grounds of Lincoln Center. The Greys and a crew of friends laid out 5,500 apples in the shape of a primordial Goddess forty-five feet long. As a consecration for the completed *Goddess*, Allyson sat at the heart center nursing daughter Zena while Alex performed one hundred prostrations at the feet of the figure. The creation of the figure was a ritual acknowledgment of our source of life, the Mother Earth, who nourishes us and whom we must

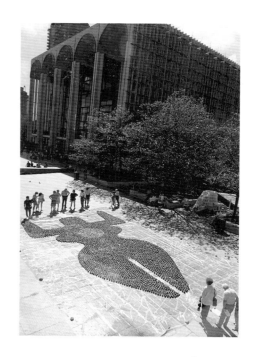

25

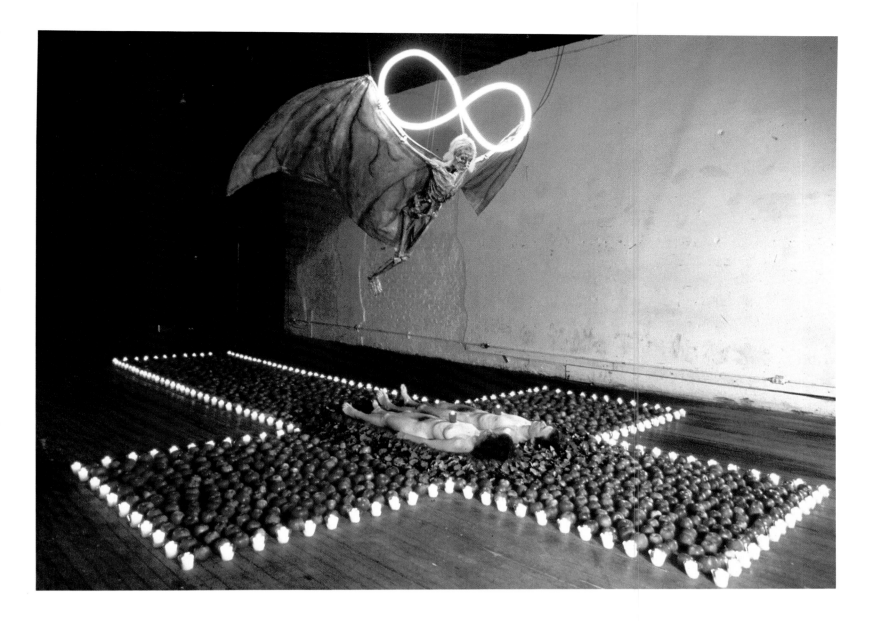

LIVING CROSS
Randolph Street Gallery, Chicago, 1983

preserve if we are to survive. At day's end friends assisted the Greys in reboxing the apples which were then donated to a shelter for homeless families.

Grey's performance work since the early eighties had become increasingly sculptural, focusing on activated mixed-media installations. The direct inspiration for the *Sacred Mirrors* came from the performance, *Life Energy,* in which audience members participated with the artist in various experiments to get in touch with their own life energy. Simple life-sized charts of the nervous system and subtle energy systems (acupuncture, chakras, auras) were displayed to allow the audience to stand before them and mirror their own systems. In the *Sacred Mirrors,* it was the artist's intention to create an installation which would function as a psychotronic device for the transformation of the viewer/participant, that is, a device powered by the psychic energy of consciousness of both viewer and artist. Each system is painted in its ideal and healthy form, so that the viewer can use it for healing and transformative contemplation.

The first exhibition of the *Sacred Mirrors* (at which four of the paintings were on view) was held in 1980 in Danvers, Massachusetts, at the Fifth International Conference on Transpersonal Psychology. Grey marked a space on the floor in front of each painting at which the viewer should stand. On the wall adjacent to each painting, a drawing/statement explained the purpose of the mirroring effect and asked the viewer to hold arms to the side, face the image, and sense the system inside or surrounding the body. People lined up to experience or "perform with" the paintings as a consciousness-raising tool. The

Sacred Mirrors, like Grey's earlier *Mindfold* project, invited the participation of the viewer for maximum effectiveness.

The full twenty-one framed *Sacred Mirrors* were first exhibited in 1986 at the New Museum in New York City. In their collected and assembled form the impact is like a crystallized hallucination. The works stretched for over 150 running feet and towered above the viewer at a height of ten and a half feet. The frames, elaborately carved and painted gold on black with stained-glass inserts, created a seemingly endless row of colored light. The thousands of hours of labor required to produce such a body of work recall a period in art history when devotional labor was at the core of art production. Yet a closer look at the overall symbols and images of the frames calls up contemporary and future images and genres of art. The viewer's mind is overloaded with information and gropes for categories in which to place the work. Is it Realist? Surrealist? Minimalist? Maximalist? Post-Modern? Psychedelic? Abstract? Religious? Medical? Scientific? or Visionary? Even if the viewer is not familiar with all the subject matter presented, there is an overwhelming impression of encyclopedic scope, and a sense of the sacred intent which produced the art.

LIFE ENERGY
Helen Schlien Gallery, Boston, 1978

The viewer must then experience each frontal human image, one at a time. *Sacred Mirrors* begins with a leaded mirror mosaic, called the *Material World,* representing the silhouette of the human form etched with symbols from the periodic table. One's whole image of the body and its surroundings is fractured and obstructed by the etchings and the lead. A frustrated and amusing attempt at viewing the self results as one reads the body broken down and reduced to its elements and compounds. The next six paintings in the *Sacred Mirrors* strip the body of its skin, exposing the various anatomical systems. One gets a sense that the physical body is an evolutionary miracle of complexity.

After the anatomical systems come six individuals, painted with extreme realism. One is confronted with the vulnerability and strength of these anonymous naked people and experiences his or her own sexuality and perception of race.

The next three paintings, *Psychic Energy System, Spiritual Energy System,* and *Universal Mind Lattice,* present the subtle energies which animate the body and soul. Standing before these paintings the viewer identifies with the energy flow and crackling dissolution of the body into infinite light. After the self has been revealed as a unified field of transcendental energy, one approaches an image of one's being in a primal and formless state, that of the *Void/Clear Light.* The central shaft of light in the painting is like a passageway from the experience of being Light, to a state beyond depiction which can only be pointed to with symbols.

Beginning with the complex Tibetan Buddhist *Avalokitesvara,* one is called to reflect on spiritual beings who embody a fully-realized state. Ideally, one identifies with the enlightened being who is one's own Buddha nature, Christ consciousness, or the wisdom of Sophia.

The last panel, *Spiritual World,* returns to a reflection of one's own personal body in an actual mirror but with an illuminated light grid radiating from the heart. With this final panel the cumulative effect of the entire series is crystallized into a realization of God in oneself.

As we have seen from Grey's teenage self-portraits and throughout his performances, his artistic quest has been a search for the self. We've used the analogy of the ordeals of the shaman which eventually lead to the capacity to assist in healing others. The process of ego death (experienced symbolically as a descent into the realm of the dead) provided the artist/shaman with instructions not only about healing, but also about the collective quest for meaning of his

tribe or culture. The *Sacred Mirrors* and subsequent paintings are Grey's presentation of his healing visions and his response to the collective quest.

In the *Sacred Mirrors,* Grey has come to an understanding of the self in its universal aspects. His philosophical insights in the early work were about the coexistence of polarities such as logic and intuition, self and surroundings, and life and death. The *Sacred Mirrors* are plotted on a course of self-discovery that acknowledges and unifies the polarities of human existence. They also represent a philosophical breakthrough for the artist, because he was able to present the multidimensional aspect of the self in one consolidated work, like one book with many chapters. Body, mind, and spirit are revealed in the *Sacred Mirrors* as reflections of nondual self-awareness or the Awareness which transcends all polarities. There is a parable that says, "when a finger points to the moon, the finger should not be mistaken for the moon." In the same way, the *Sacred Mirrors* point to the self which is the beyond within the viewer.

BIO-PSYCHEDELIC HUMAN RELATIONSHIP PAINTINGS

From 1983 to 1985, Alex Grey executed a considerable body of paintings that deal directly with how the various planes of bio-psychic energy pass through and between pairs of bodies involved in different processes of human interaction. Among the many remarkable works we might consider are illuminatory paintings such as *Kissing, Copulating,* and *Nursing.* The titles are descriptive and direct as the pieces themselves. In fact, there is something so scientifically precise about them, that they appear to be illustrations—a characteristic which along with their undeniably mystical bent may account for the persistent resistance they have encountered in the art world to date. They blur the artificially established line between science and art, and obliterate the nominal distinction between idiomatic perception and universal fact. What can and should be said about these paintings is that they formally put into use the entire scheme of life energy systems Grey systematically mapped out in the *Sacred Mirrors.* Visually akin to the sort of x-ray readings a psychic healer might describe, these paintings peel away the skin of existence to reveal the anatomical circuits of veins, nerves, organs, and skeletal structures, as well as the emanations of metaphysical reality such as auras, chakras, brain waves, and sight lines of human optic and cognitive recognition. Grey examines the biological, sensory, and spiritual modes of behavior that occur in *inter* and *intra* human phenomena, depicting them in pictures of people joined together in acts of cathexis (kissing, making love, and breast feeding). His view is one of alchemical clairvoyance and laboratory-like reductivity of all extraneous outside elements. He traces his impressions of the frequency and presence of these transcendental effects with a visionary vocabulary that includes glowing auras delineated by flames, and thin luminescent lines—radiating over the picture plane in focal grids of renaissance perspective or speeding across it in transparent, intricate webs of minute electrical currents.

MYTHIC, TRANSCENDENTAL WORLD SOUL PAINTINGS

In his current work, Grey is leaning toward making large-scale, epic paintings in the bio-illuminatory style discovered in the *Sacred Mirrors.* Using historically recognizable mythology in a contemporary context, Grey creates a modern parable about the global and societal state of today's world. Grey's visions arise from contemporary collective consciousness and affirm in the face of a largely secular society the potential for authentic and contemporary sacred art.

Among the grandly conceived paintings Grey has completed since 1985 are pictorial retellings of archetypal experiences. Here we see the violent, contemporary spiritual quest in *Journey of the Wounded Healer,* in *Holy Fire,* the purification which leads to transcendence; in the cosmically panoramic *Theologue: The Union of Human and Divine Consciousness Weaving the Fabric of*

Space and Time in Which the Self and Its Surroundings Are Embedded, a massive five by fifteen foot painting specifying the geometric convergence of personal and universally spiritual points occurring during meditation. The erotically explicit portrayal of various forms of sexual intercourse in *Deities and Demons Drinking from the Milky Pool* represents the sacred and profane desires of mankind around the axial sectors of divine and deviant practice; and *Gaia* provides a mind-bending vision of a world poised on the brink of either self-destruction or self-preservation. This elucidation of present-day experience through alternative theological fables finally takes us directly to the studio of the artist.

Alex Grey's studio continues to be a launching site for new ventures to the furthest possible unexplored regions of micro-biological and macrocosmic consciousness that body, mind, and spirit may some day eventually discover in humankind's search for the true and immutable self. According to Grey, this passage represents the only viable course for individual and culture to take if either is to survive. It is both the question and the answer, the beginning and the end of all things great and small; and Grey is a tireless journeyman, on a pilgrimage that is both an act and an art of uncompromising faith.

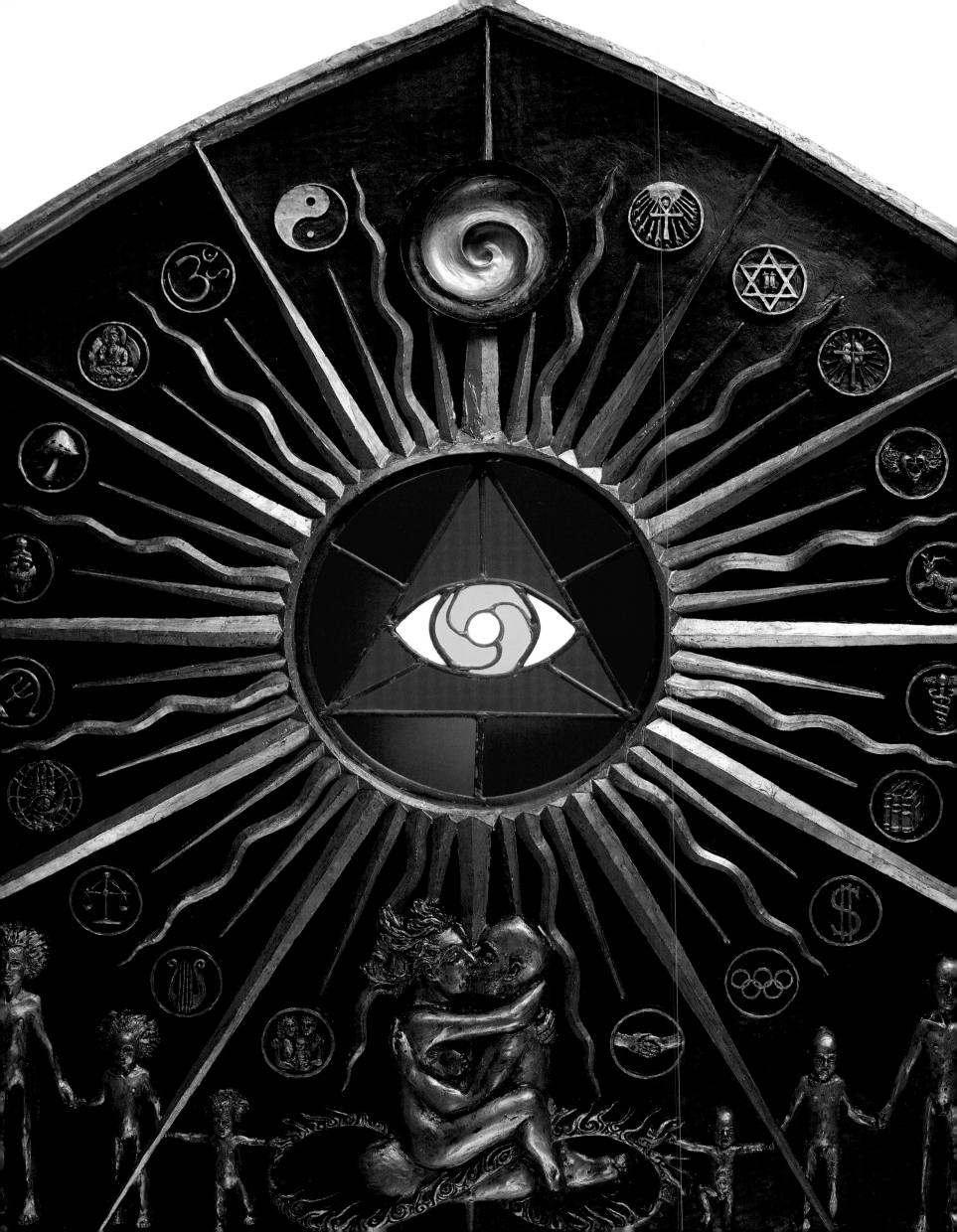

THE SACRED MIRRORS

Alex Grey

The nature of the mind is like a mirror which has the natural and inherent capacity to reflect whatever is set before it, whether beautiful or ugly; but these reflections in no way affect or modify the nature of the mirror. It is the same with the state of contemplation: There is nothing to correct or alter or modify. What the practitioner does when entering into contemplation is simply to discover himself in the condition of the mirror.

Namkhai Norbu
SELF-LIBERATION THROUGH SEEING WITH NAKED AWARENESS

Sacred art objects are like repositories of transcendental energy that can "charge" the receptive, contemplative viewer. The artist's primary medium is consciousness—the animating force that directs or infuses all other media. Inspiration for the *Sacred Mirrors* emerged after I had a series of mystical experiences that caused me to redefine my view of consciousness and the self. I felt that my body was no longer just a solid, isolated object in a world of separate forms and existential anxiety, but more like a manifestation of the primordial energy of awareness that was everywhere present. The mystical experience is not some dreamy fantasy, as anyone who has had one can agree. Psychological research into the mystical experience has yielded the following definition: a sense of profound unity within oneself and with the outside world; a transcendence of space and time or a feeling of being in touch with infinity and eternity; a sense of sacredness, awe or numinosity; a sense of the supreme reality and truth of the insight; the embracing of paradoxes or transcendence of duality; ineffability; and overall positive affect.[1] The mystical experience is a transformative contact with the Ground of Being and, although it is beyond description, it gives people an expanded appreciation of life. During times of cynicism and despair, experiences that empower people to heal conflicts and choose life are especially valuable. I wanted my paintings to visually chart the spectrum of consciousness from material perception to spiritual insight; and to function, if possible, as symbolic portals to the mystical dimension.

The *Sacred Mirrors* are a series of twenty-one images, consisting of nineteen paintings and two mirrors, that examine in fine detail the human physical and metaphysical anatomy. Each image is forty-six by eighty-four inches and pre-

SACRED MIRRORS frame detail
with illuminated stained glass

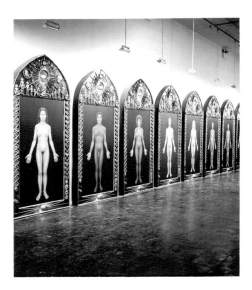

sents a life-sized figure directly facing the viewer, arms to the side and palms forward. This format allows the viewer to stand before the painted figure and "mirror" the image. A resonance takes place between one's own body and the painted image, creating a sense of "seeing into" oneself. The *Sacred Mirrors* may be used as a tool to visualize and focus healing energy to particular parts of the physical and metaphysical bodies.

Surrounding each image is a sixty by one-hundred-twenty-six inch arched frame specifically designed for the *Sacred Mirrors*. The frames feature a brief "history of the universe," and provide a philosophical framework in which to view the *Sacred Mirrors*. In the center, at the bottom of the frame, is a golden explosion of rays symbolizing both the Genesis of God's light and the "Big Bang." Moving up the left side are spinning galaxies, the earth's solar system, and the earth, out of which spirals a double helix of DNA. Within the rungs of the DNA molecule is biological evolution, "the tree of life," represented in seventeen steps, from blue-green algae to early man. At the bottom of the right side are comparative profiles and brains of the ape, dawn man, and modern man. A double helix of serpents, representing upward evolution, spiral out of the right and left hemispheres of a human brain each ouroborically biting the tail of the future. The serpents, symbolic of the temptation of the tree of knowledge and of subconscious opposing forces which drive the evolution of consciousness, frame symbols of the progressive steps of technological evolution from the stone age to the space age.

Central to the arched top of the frame, an illuminated stained glass "Eye of God" serves as the radiant center of a Wheel of Life. On the horizontal spokes or radiances of the Wheel are balanced the opposites of birth (fetus) and death (skull), and on the lower vertical radiance, the union of opposites is expressed as embracing lovers. On either side of the lovers are represented the stages of life from infancy to old age. The male and female elders are seated and hold the future of biological and technological evolution in their hands.

The apex of the frame contains an original symbol called the Polar Unity Spiral. The symbol developed from a psychedelic vision in which I experienced a spiritual rebirth canal as a tunnel inside my head, continuously spiralling from darkness into light. Similar experiences of a journey through a dark tunnel toward the light are described in mystical literature, scientific papers on altered states of consciousness, and reports of near death experiences.[2] Symbols of the paths of life—business, education, family, the arts, medicine—radiate from the lower hemicircle around the Eye of God. Wisdom paths indicated by symbols from some of the world's great religions radiate from the upper hemicircle.

The sphere of light at the bottom center of the frame (Genesis), the Eye of God at the upper center of the frame, as well as the gothic arch pointing heavenward support the theme of the *axis mundi* (spiritual axis), which is reiterated several times in different ways throughout the *Sacred Mirrors*. The *axis mundi* or universal tree grows from its roots in the physical world upward, inward, and toward higher states of consciousness. The infinitely complex branching of the neurons in the neocortex of the human *Nervous System*, developed from billions of years of evolution, is one example of this tree-like growth. The yogic chakras in both the *Life Energy System* and the *Psychic Energy System* display a material to spiritual progression. The *Psychic Energy System* also includes the stations of the Kabalistic tree of life that parallel the hierarchy of the chakras.

The series of twenty-one paintings divides into three equal sections generally described as body, mind, and spirit. The entire progression of the series from *Material World* to *Spiritual World* describes a process of transformation from body consciousness to spiritual consciousness.

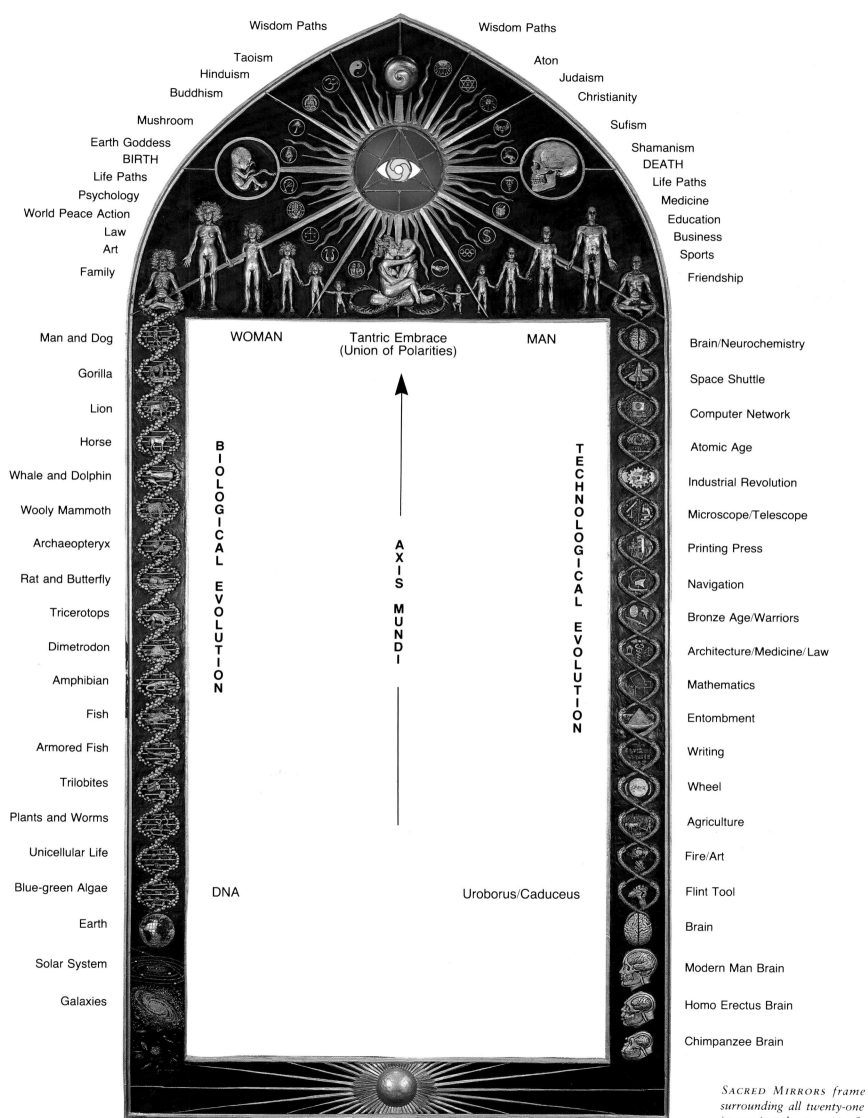

Polar Unity Spiral

Wisdom Paths Wisdom Paths

Taoism Aton
Hinduism Judaism
Buddhism Christianity

Mushroom Sufism
Earth Goddess Shamanism
BIRTH DEATH
Life Paths Life Paths
Psychology Medicine
World Peace Action Education
Law Business
Art Sports
Family Friendship

WOMAN Tantric Embrace MAN
(Union of Polarities)

Man and Dog Brain/Neurochemistry
Gorilla Space Shuttle
Lion Computer Network
Horse Atomic Age
Whale and Dolphin Industrial Revolution
Wooly Mammoth Microscope/Telescope
Archaeopteryx Printing Press
Rat and Butterfly Navigation
Tricerotops Bronze Age/Warriors
Dimetrodon Architecture/Medicine/Law
Amphibian Mathematics
Fish Entombment
Armored Fish Writing
Trilobites Wheel
Plants and Worms Agriculture
Unicellular Life Fire/Art
Blue-green Algae Flint Tool
Earth Brain
Solar System Modern Man Brain
Galaxies Homo Erectus Brain
 Chimpanzee Brain

BIOLOGICAL EVOLUTION

AXIS MUNDI

TECHNOLOGICAL EVOLUTION

DNA Uroborus/Caduceus

Big Bang/Genesis

SACRED MIRRORS frame surrounding all twenty-one images in polyester resin, fiberglass, wood, illuminated stained glass, 126 × 60 in.

The *Sacred Mirrors* begins with a piece entitled the *Material World,* that has over 100 actual mirrors sandblasted with symbols of all the known elements of the periodic table. A grid of lead strips welds the mirror/elements to a lead silhouette of a human figure. Deeply inscribed into the surface of the lead silhouette are the complex arrangements of elements that produce the biochemical constitution of the human body. When one sees oneself reflected in the *Material World,* the image is fractured, distorted, and completely obscured in the center of the mirror because of the opacity of the lead body.

The *Skeletal System,* that is the last of our physical remains, begins the examination of the gross anatomy. The skeleton is also the archetypal symbol of death. The initiatory ordeal of shamans (of various cultures) requires contemplating one's own skeleton and naming the bones in a sacred tongue to induce the mystical experience of death and resurrection. Made up of 206 bones, the skeleton provides the inner scaffolding and determines the primary outer design of the body, and as such is an architectural and engineering masterpiece. The shapes of bones differ according to the tasks they perform. The plate-like bones of the cranium protect the brain. The spine, which contains the delicate spinal cord, has twenty-six complex interlocking vertebrae separated by shock absorbing pads.

The *Nervous System* presents the integrating master of all other systems in the body and the ultimate anatomical vehicle of consciousness. The nervous system gathers all sense impressions, coordinates all actions, and is the channel for all feeling and thinking. The seed and source of this system, the human brain, is made of trillions of intricately interwoven cells, and is the most complex and mysterious object known to humanity.

The mountain of knowledge about the nervous system grows each day, yet how the complex interaction of individual cells leads to our experience of consciousness, and a centralized concept of self with focused awareness, will never be understood from a strictly anatomical perspective. The brain understanding the brain is like a dog chasing its own neuronal tail; helpful knowledge and theories will develop, but the mystery of the mind remains.

The *Cardiovascular System* presents the heart, that fountain of life blood, surrounded by a network of the most intricate plumbing. The cardiovascular system takes food and oxygen to trillions of cells throughout the body, and carries away waste matter. It consists of the arteries (red) which channel fresh oxygenated blood from the heart, and the veins (blue) which carry CO_2 laden blood back to the heart. The heart pumps the "blue" blood into the lungs through the tiny capillaries surrounding the alveoli (small air sacks) of the lungs where the gases are exchanged. Reoxygenated blood is then carried back to the heart for another round trip. The pumping heart circulates an average of six to seven quarts of blood through the body about seventy-two times a minute, or approximately two and one-half billion beats in a normal lifespan.

The *Lymphatic System* presents a network of vessels, nodes, and lymph-producing organs crucial to the body's immune response. The immune system determines that which is "not self" and then fights it off. Vital to locating and destroying these microscopic "intruders" are the T-cell lymphocytes, produced by the thymus gland, located near the heart. The spleen is also a source of lymphocytes. The lymph vessels collect the "drainage" of lymphocytes and macrophages from the capillaries and then modify or return them to the blood system, draining into the veins near the heart. The new science of psychoneuroimmunology studies the interaction of psychological factors such as stress with the immune system, and a convincing body of evidence links various personality factors with health and disease.

The painting of the *Viscera* shows a man flayed open exposing heart, lungs,

stomach, liver, intestines, and the brain. The digestive system is one long tube that carries food through the processes which break it into energy and waste. The lungs supply our bodies with essential oxygen and remove carbon dioxide. The liver is the great storehouse and processor of food, breaking it down into useful amino acid chains. The liver also protects the body by collecting ingested toxic substances, chemically treating them, and rendering them harmless. The phrase "That takes guts!" ascribes a source of emotional bravery and an emotional depth to our "guts." Anxiety churns up stomach acid and can tie our intestines in knots. Our gut reactions are simply the most primal feelings we have toward stimuli.

In the *Muscle System* we see a woman, strong and pregnant, with a window cut away to reveal her delicate eight-month-old fetus. The muscles of the abdomen go through an incredible expansion during pregnancy—an archetypal example of the transformative potential of the body. The muscles weave around the skeleton and provide the opposing forces needed for body movement. Connected to the bone by tendons passing across the joints, the muscle fibers contract or pull together to perform motor movements. Many different shapes and sizes of muscles harness the body together. Extremely tiny muscles perform functions like contracting the arteries or contracting the bronchial tubes of the lungs. The muscles determine the superficial appearance of most of the surface of the body.

Each painting in this section of the *Sacred Mirrors* is based on anatomical atlases and actual dissections, and depicts the anatomical systems with careful accuracy.[3] Though thoroughly dissected, the figures stand and stare with moist eyes as if healthy and alive. They reflect our own mortality. The inner systems reflect a profound, shared human experience and a miracle of nature which we rarely appreciate, unless the systems are disturbed or unveiled. The approximately sixty trillion cells in the adult body are dying and being replaced at the rate of 5 million per second, and yet this unfathomably complex whole system, the body, is only our physical vehicle.

The second section of the *Sacred Mirrors* roughly corresponds to our function of mind, and can be said to focus on the mind's most superficial level of perception—sociopolitical perceptions conditioned by our prejudices and sympathies concerning appearances. The skin, the largest organ of the physical anatomy, denotes our individuality. Whereas many of the inner systems exist similarly in all people regardless of race or sex, skin makes our differences obvious. The *Sacred Mirrors* shows a man and a woman of each of three races: Caucasian, African, and Asian. The viewer is presented with the challenge of seeing oneself reflected in others, as a member of another race or sex, and feeling prejudices and sympathies as they arise.

The *Psychic Energy System* is the crux of the *Sacred Mirrors* because it presents an X-ray view of the physical body and interweaves the non-physical or psycho-spiritual energy systems. It also introduces the next phase of the *Sacred Mirrors,* a complex variety of nonphysical or esoteric energy systems and spiritual archetypes which could be called the metaphysical aspect of the human being.

The *Psychic Energy System* was created from descriptions by clairvoyants and aura readers of the colors and shapes of the astral and etheric auras surrounding the body, the seven central chakras, and the golden white light of the acupuncture meridians and points. According to Hindu yogic tradition and psychic analysis there are seven primary chakras or wheels of metaphysical energy located along the central axis of the body. The chakras mediate the energies of the egg-shaped astral and other higher "bodies" with the etheric energy layer closely surrounding and interpenetrating the physical body. The chakras present a model hierarchy of the evolution of consciousness or its

development. The lowest chakra, situated in the genital region, is the source of the primal hungers and drives. The second chakra corresponds to the emotions and "gut reactions," and is the primary connection point between the emotional or astral body and the physical. The third chakra corresponds to reason and intellect, and connects the physical to the mental body. By the time we are young adults these three chakras are open and functional, that is, channelling essential bio-energy—it seems they are God-given properties of normal human development. The development of the next four chakras depends on awakening an awareness of the higher self, beyond the ego, and takes one more consciously toward self knowledge and self realization. The heart chakra is the channel of love and provides the first opportunity we have to become transrational. Positive development of the throat chakra channels divine will and higher authority and represents the capacity to lead. The third eye opens one to creative spiritual vision—it is also the tunnel to the highest chakra. The opening of the highest chakra is the goal of yoga, the experience of the union of God and Self.

The color of blue purple was chosen as the predominant color for the *Psychic Energy System* because according to renowned clairvoyant C. W. Leadbeater and other psychics, blue purple represents high spirituality. The entire body is immersed in and interpenetrated by an oceanic lattice of energy which represents the *prana*, or vital ether, one of the pervasive life-supplying energies recognized in both Eastern and Western occult spiritual traditions. Although these subtle systems have formerly been unverifiable by scientific means, in recent years scientists in Japan, the U.S.A., and U.S.S.R. have teamed up with psychics and devised instruments and experiments capable of monitoring some of these energies.[4]

OM
Sanskrit mantric seed-syllable

The Hebrew symbols located on the *Psychic Energy System* represent the Kabalah, the cosmological tree of life of Jewish mysticism. The Kabalistic tree, when keyed to the human body is known as the Adam Kadmon or First Man, and denotes the emanation of the highest spiritual world from above the head down through the physical world at the feet. The symbols represent ten divine attributes such as wisdom, mercy, judgment, and beauty. Inside the seven chakras, which present a similar spiritual-to-physical spectrum, are the Sanskrit symbols indicating the sounds and meanings of each energy center, according to Hindu tradition. For example, the highest center, located above the crown of the head, the "thousand-petaled lotus," contains the mantric symbol *Om,* the primordial mantric resonance of the infinite and eternal.

The *Spiritual Energy System* is an image of heightened awareness. The body has become a permeable channel for the circulation of the subtle and fine energies of spiritual consciousness that are ever-present and interpenetrate the self and surroundings. Parallel lines of force stream through the body extending out of the crown of the head and curling back around to the feet, creating a toroidal flow.

The *Universal Mind Lattice* portrays an advanced level of spiritual reality that transcends the physical body and all material objects. The Self is seen as a torus-like energy cell, a fountain of consciousness within an infinite, omni-directional network of similar cells. The Self is distinct from every other cell, and at the same time, in complete union with all energy centers in the network. The surrounding cells represent the energy source of every other being and thing. The energy of the *Universal Mind Lattice* is love. The unified network of energy bodies represented in the painting could be called the Body of God, the Atman in the Brahman, or the fabric of being, beyond space and time.

The last section of the *Sacred Mirrors* presents the spiritual realm through a portrayal of some of the world's religious archetypes. The *Void/Clear Light* is a nondual perfected state of being which is boundless, ultimate, and indescrib-

able. To portray the indescribable I rely on a central ground of blackness infused by a subtle shaft of light, surrounded on the edges by Tibetan influenced representations of the five elements—fire, water, earth, air, and space. At eye level is the Tibetan Buddhist monogram of Kalachakra. Kalachakra is the name of a specific tantra taught for centuries in Tibet. The symbol represents the 84,000 Buddhist teachings of enlightenment and the five elements transmuted by the principle of Sunyata, the emptiness of all forms. This is the emptiness that is the Ground of all Being and potential of all worlds.

In the Hinayana (lesser vehicle) tradition of Buddhism, the Arhat is one who harms no one, quells the passions, attains the transcendence of the Void/Clear Light, and gets off the wheel of suffering and rebirth. In the Mahayana (greater vehicle) tradition, the Bodhisattva, "one whose being is enlightenment," has attained the highest state and vows to return to the community to help relieve suffering and bring benefit and, ultimately, Liberation to all beings. These two Buddhist paths explain the transition in the *Sacred Mirrors* from the Void/Clear Light to the radiant embodiments of wisdom and compassion.

The next painting, *Avalokitesvara*, is a major archetype in Tibetan Buddhism, and represents the Great Bodhisattva as a tantric manifestation of active compassion. The most popular mantric prayer in Tibet, "*Om Mani Padme Hum,*" (Hail the Jewel in the Lotus) is directed toward Avalokitesvara, who is also known as the lotus bearer. The lotus is one's life or the world, that which goes through transformation, like the lotus. The jewel is the precious enlightenment of mind. It is said that when Buddha saw the suffering of the human world, he sprouted one thousand hands and arms to assist the world, each palm containing an eye of unobstructed vision.[5] From the nondual perspective of the enlightened one, nirvana and samsara, voidness and active compassion, are recognized as equally sacred aspects of the whole. The name Avalokitesvara can also be interpreted as "The Lord seen within," giving away the ultimate teaching that all beings in all realms from the hell realms to the human and angelic realms have Buddha nature. The Dalai Lama is recognized as the earthly manifestation of Avalokitesvara.

In my painting I show three levels (Trikaya) of manifestation of the Buddha. First, the manifestation of Buddha in the physical world, or the "Nirmanakaya realm," is the Gautama Buddha in the lower right-hand corner of the painting, surrounded by disciples or monks and the three people who inspired Prince Gautama's quest for enlightenment: a sick man, an old man, and a dead man. The second level of manifestation is the Sambhogakaya, the clear luminous tantric realm where Avalokitesvara's consort, Green Tara, the merciful protectress of Tibet appears (lower left). The terrifying aspect of the Buddha of transcendental knowledge (lower right) is represented by the Dharma-protecting Vajrabhaivara in yam yub (divine copulation) whose rage is so complete he destroys even himself. The third realm of manifestation of the Buddha is the Dharmakaya, which is the universal omnipresent essence of the Buddha, the ultimate state of clarity and emptiness, here represented by countless golden Buddhas, each with a tantric mudra or symbolic hand gesture.

The main figure, *Avalokitesvara,* is a magnificent Sambhogakaya presence with gift-bestowing benefits and ego- and delusion-binding instruments in his hands. A complex psychology is embedded in the Buddha's eleven heads which include Yama, the Lord of Death, directly preceding Amitabha, the Buddha of Boundless Light.

Christ was one of the first Western spiritual teachers to realize and activate the essential truth that he was (we are) "The Word made flesh"—a direct channel for the love and healing energy of God. "I am the light of the world," he said. In the *Sacred Mirrors,* Christ is shown resurrected, surrounded by

golden light, with two angels: Gabriel (left) is holding a book on which a symbol of the trinity appears; Michael (right) exhibits the compassion that subdues evil but does not kill it. A flaming infinity band of love encircles the Sacred Heart, and whirling six-pointed stars on either side of Christ's head refer to Christ's mystical origins. The six-pointed star symbolizes the primal unity of heaven and earth and the divine Father and Mother. According to the Gnostic Gospels, Christ taught that the Godhead was both male and female; he referred to both his heavenly Father and Mother (which has become the Holy Ghost or Holy Spirit).

In the Gnostic text, *Hypostasis of the Archons,* discovered at Nag Hammadi, the Goddess Sophia pre-existed and gave birth to the male Godhead, and she chastises his arrogance when he says there are no other gods before him. She says, "you are wrong, Samael," which means "Lord of the blind." And he said, "If any other thing exists before me, let it appear." And immediately Sophia (Wisdom) stretched forth her finger and introduced light into matter, and she followed it down into the region of Chaos.[6] The painting *Sophia* shows the Mother-Light—the living, guiding presence of the principle of wisdom. She is the Goddess as gnostic vessel of rebirth and spiritual transformation. Sophia is shown here as a guide for the times of crisis humanity is now facing, having embraced the entire world in her spirit-nourishing heart. Her halo, designed and painted by Allyson Grey, symbolizes wisdom beyond rational understanding. In Sophia, infinite vision and wisdom are united as one level of being. Beneath her hands are the immanent manifestations of the Goddess—the life-giving nurturing mother and Kali, the dark mother of time, birth and death.

The *Sacred Mirrors* opens with the opportunity to see oneself in the fractured mirror of the *Material World,* and closes with another mirror reflecting the unbroken *Spiritual World.* It is essentially the same world, but transformed— a world of unity and interrelatedness. In the center of *Spiritual World* is a radiant sun, located approximately where the heart of the viewer might be. According to two of the oldest Upanishads of Hindu mysticism, the *Brihadaranyaka* and *Chandogya,* composed between the ninth and the sixth century B.C., "the heart" is the region where the incarnating transcendental self resides. The illuminated heart sun radiates a network of light throughout the space in the mirror, and carved into its center is the name of the source of the light and the self. The final mirror is an invitation to reflect on oneself and others as well as on one's entire surroundings as an aspect of God, and hence, sacred.

Transformation of the world begins with transformation of oneself at the level of one's own heart. Buddha and Christ revealed the anatomy of moral and spiritual truth. Sophia is the principle of that open-hearted truth. The religious archetypes imply the question, "If we are spiritual beings created out of divine substance, how does this suggest that we live?" The world's spiritual teachings represent our highest human aspirations—a correspondence with transcendental wisdom and compassion.

The *Sacred Mirrors* presents a multi-dimensional search for the Self. The Self is recognized as that which underlies, unites, and directs the many physical and metaphysical systems. The purpose of the *Sacred Mirrors* is to reflect on and appreciate the sacredness of the individual self, one's unity with other people and cultures, and one's connectedness with the earth and universe. The *Sacred Mirrors* show that the material and spiritual worlds are only reflections of the inner sacred mirror of the Self, which can be nowhere depicted, only realized.

SACRED MIRRORS—THE PLATES

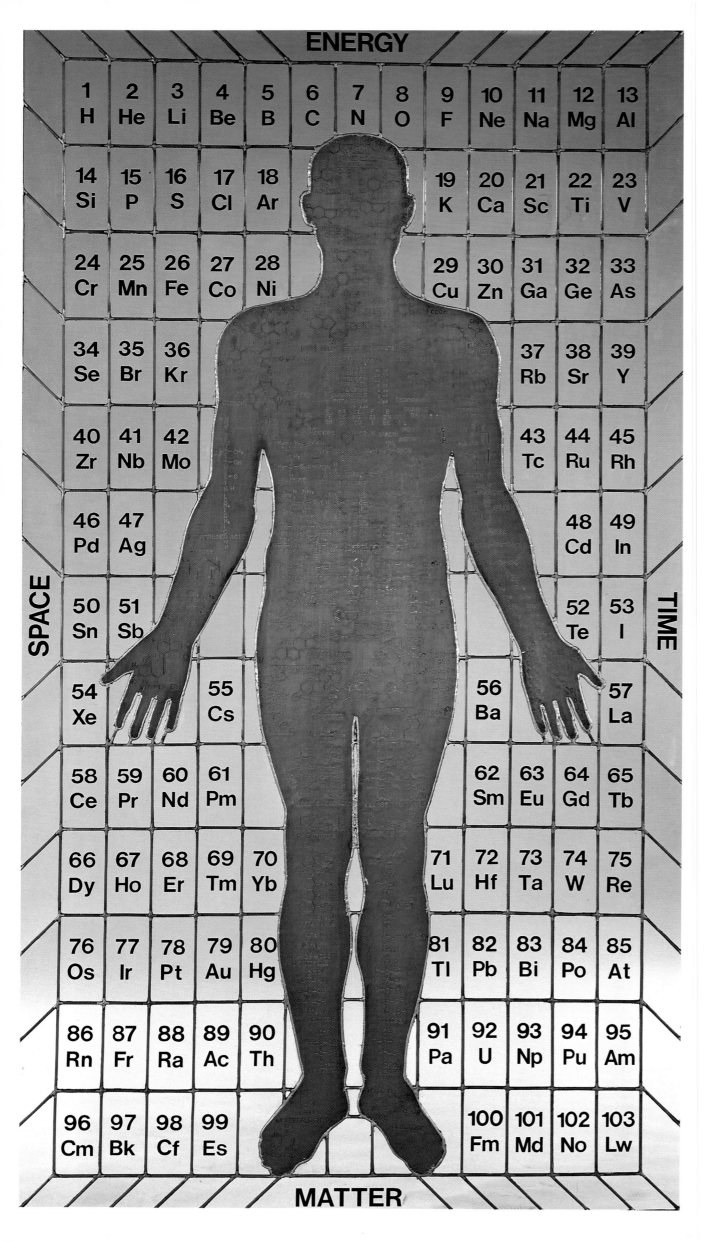

ENERGY

1 H	2 He	3 Li	4 Be	5 B	6 C	7 N	8 O	9 F	10 Ne	11 Na	12 Mg	13 Al
14 Si	15 P	16 S	17 Cl	18 Ar				19 K	20 Ca	21 Sc	22 Ti	23 V
24 Cr	25 Mn	26 Fe	27 Co	28 Ni				29 Cu	30 Zn	31 Ga	32 Ge	33 As
34 Se	35 Br	36 Kr							37 Rb	38 Sr	39 Y	
40 Zr	41 Nb	42 Mo							43 Tc	44 Ru	45 Rh	
46 Pd	47 Ag									48 Cd	49 In	
50 Sn	51 Sb									52 Te	53 I	
54 Xe		55 Cs				56 Ba					57 La	
58 Ce	59 Pr	60 Nd	61 Pm				62 Sm	63 Eu	64 Gd	65 Tb		
66 Dy	67 Ho	68 Er	69 Tm	70 Yb			71 Lu	72 Hf	73 Ta	74 W	75 Re	
76 Os	77 Ir	78 Pt	79 Au	80 Hg			81 Tl	82 Pb	83 Bi	84 Po	85 At	
86 Rn	87 Fr	88 Ra	89 Ac	90 Th			91 Pa	92 U	93 Np	94 Pu	95 Am	
96 Cm	97 Bk	98 Cf	99 Es				100 Fm	101 Md	102 No	103 Lw		

SPACE

TIME

MATTER

MATERIAL WORLD
1985–86, LEAD SILHOUETTE
AND LEADED MIRRORS
84 × 46 IN.

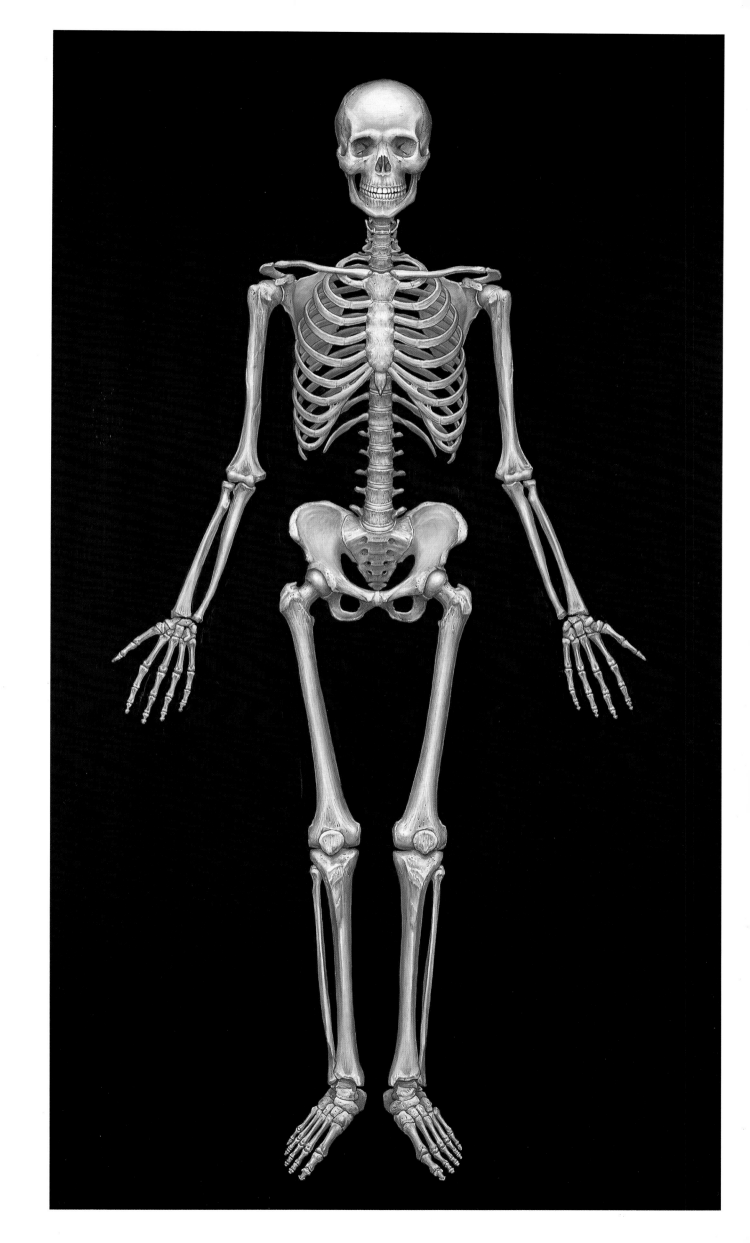

SKELETAL SYSTEM
1979, OIL ON LINEN
84 × 46 IN.

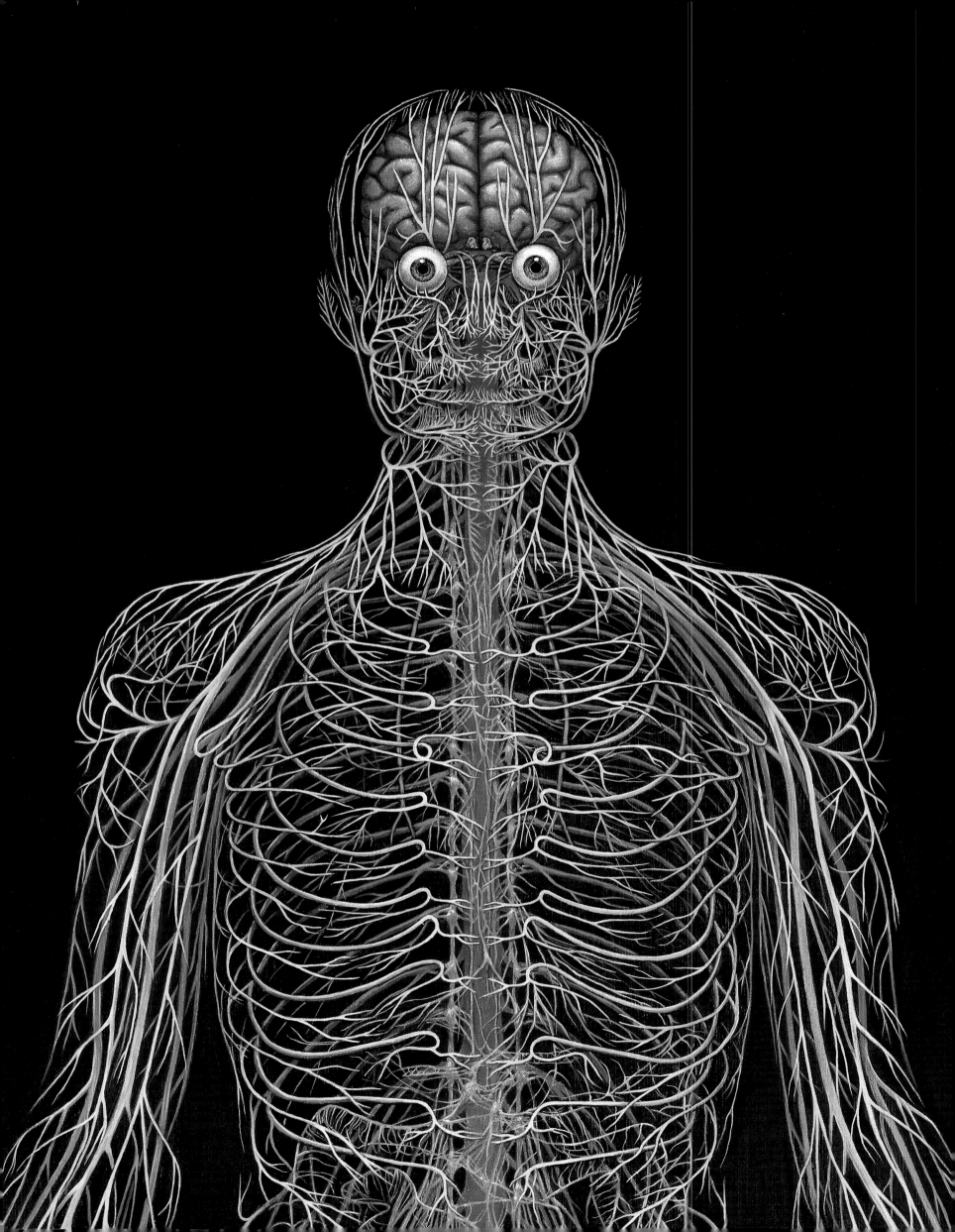

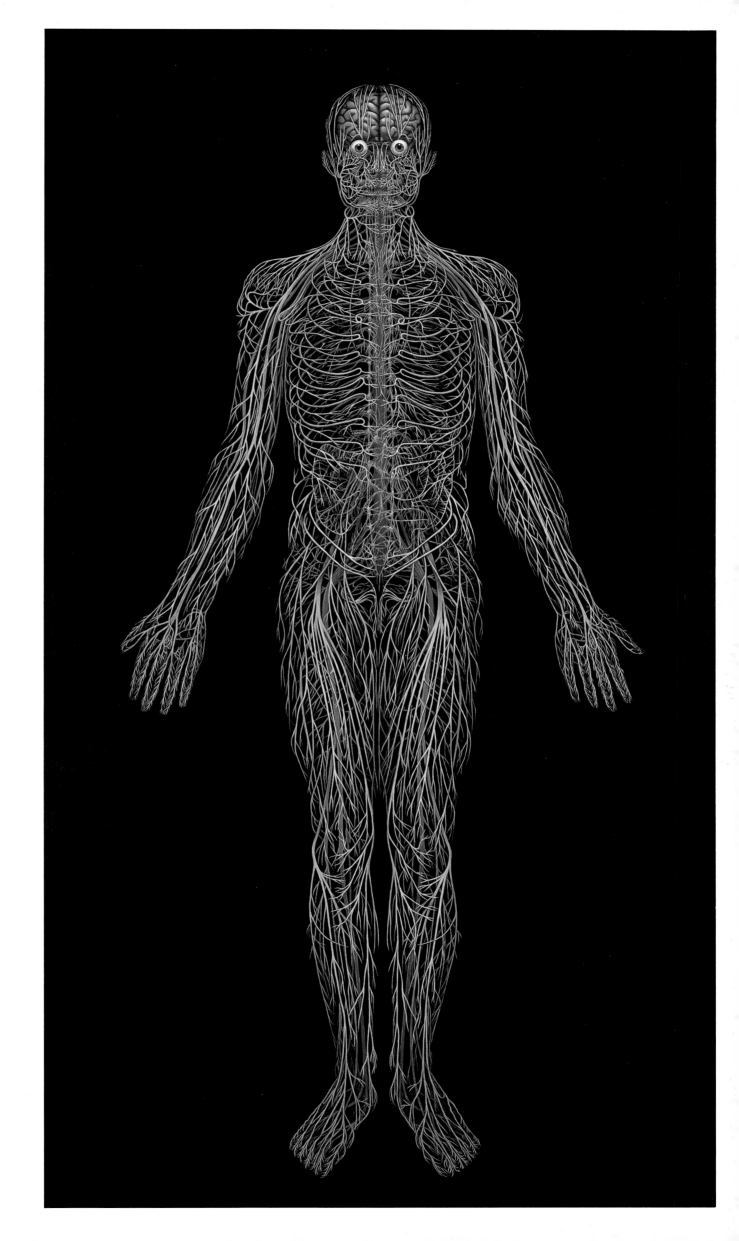

NERVOUS SYSTEM
1979, OIL ON LINEN
84 × 46 IN.

◀ NERVOUS SYSTEM
(DETAIL)

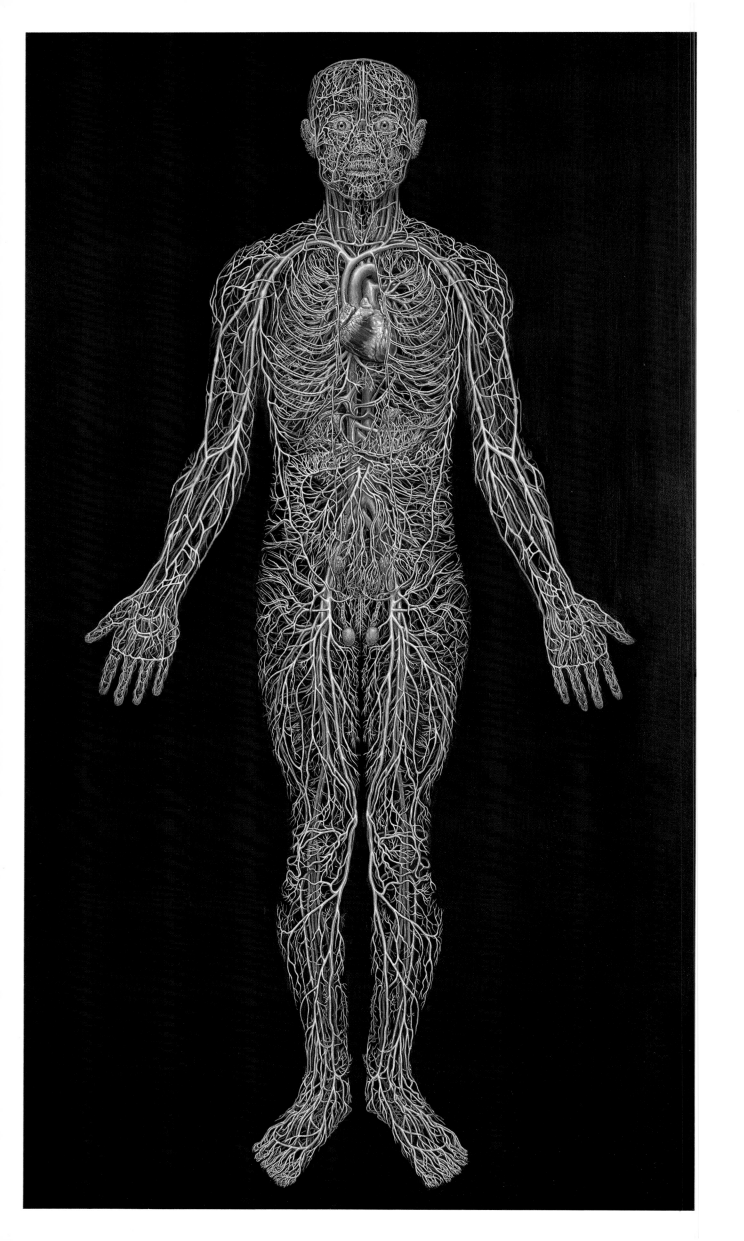

CARDIOVASCULAR SYSTEM
1980, OIL ON LINEN
84 × 46 IN.

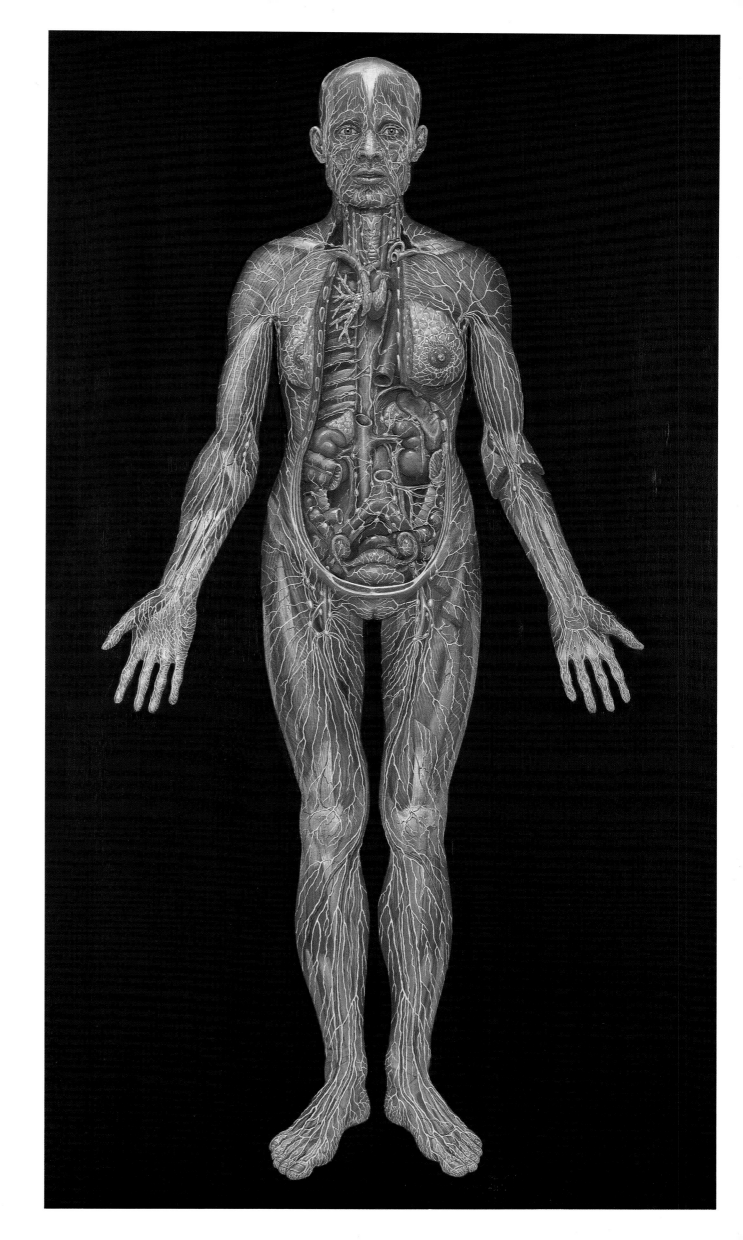

LYMPHATIC SYSTEM
1985, OIL ON LINEN
84 × 46 IN.

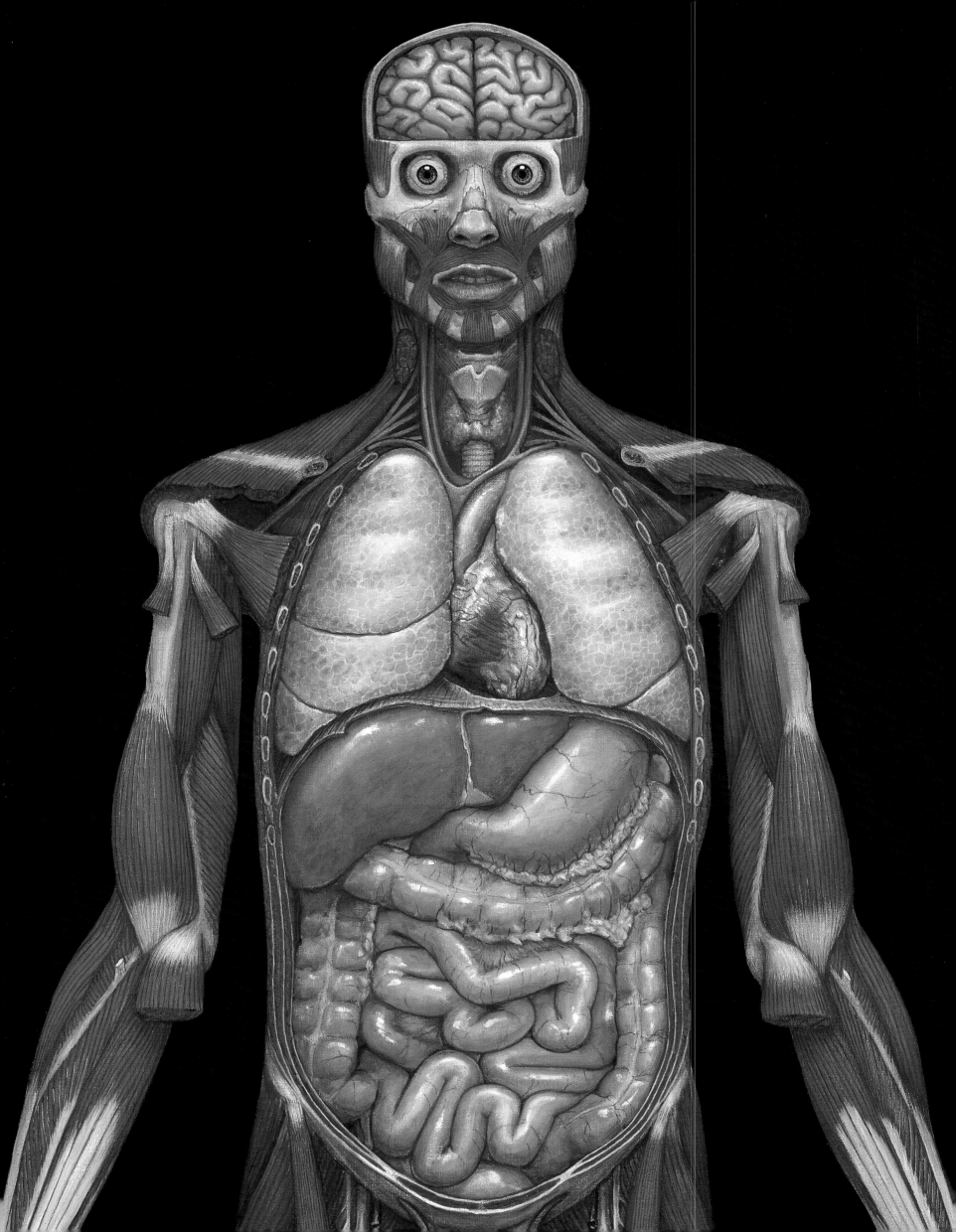

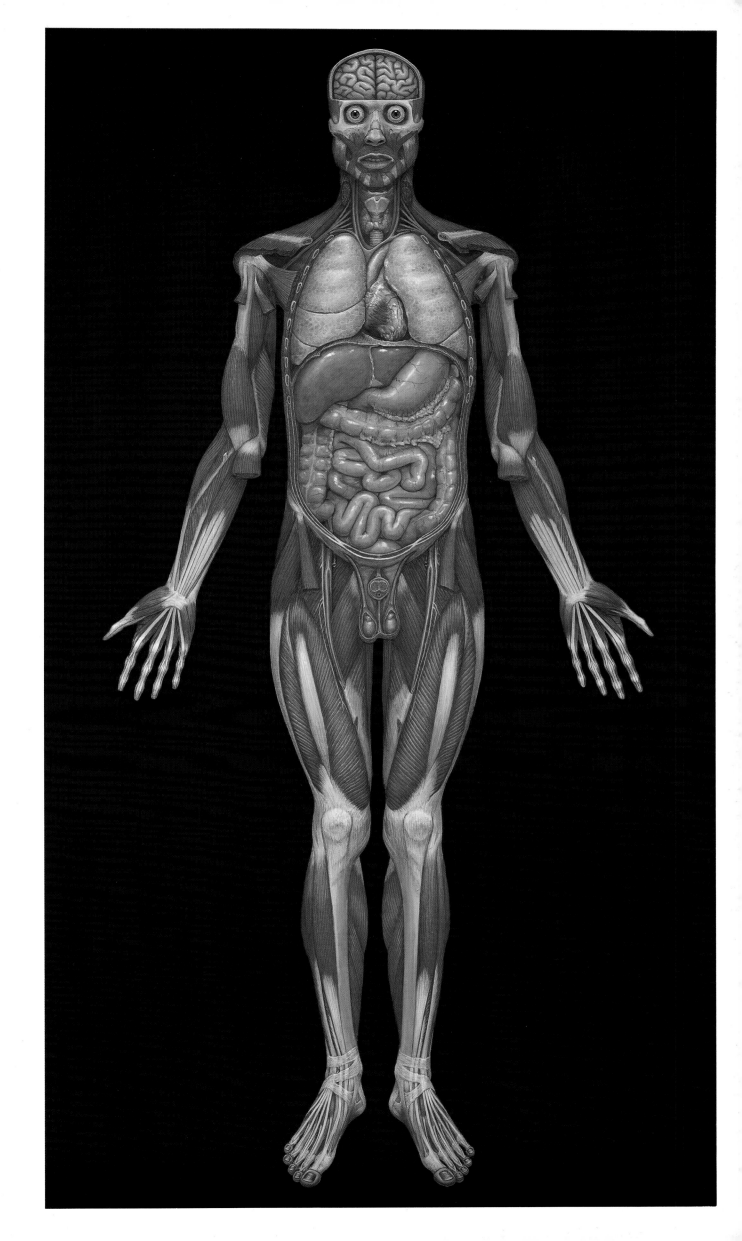

VISCERA
1979, OIL ON LINEN
84 × 46 IN.

◄ VISCERA
(DETAIL)

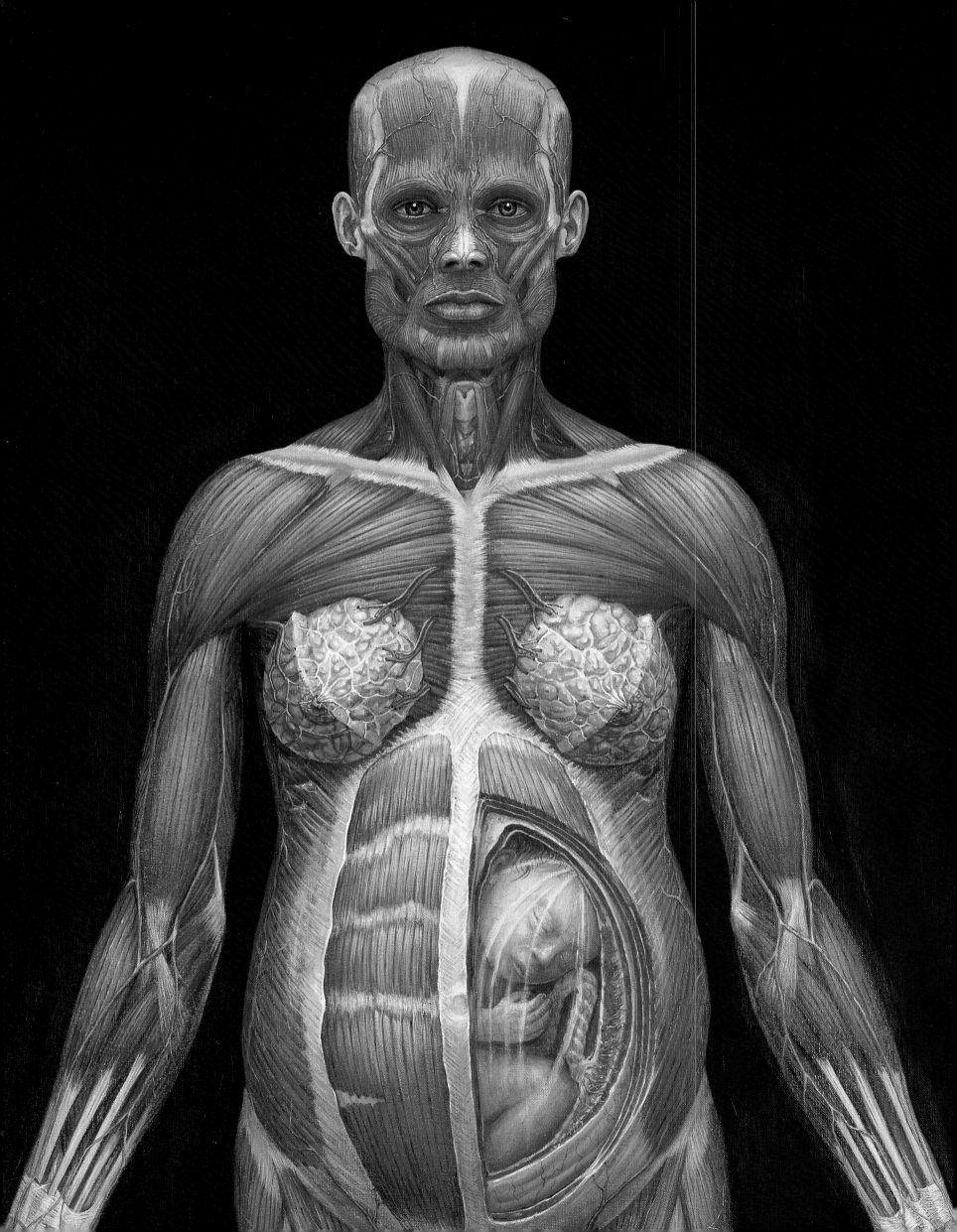

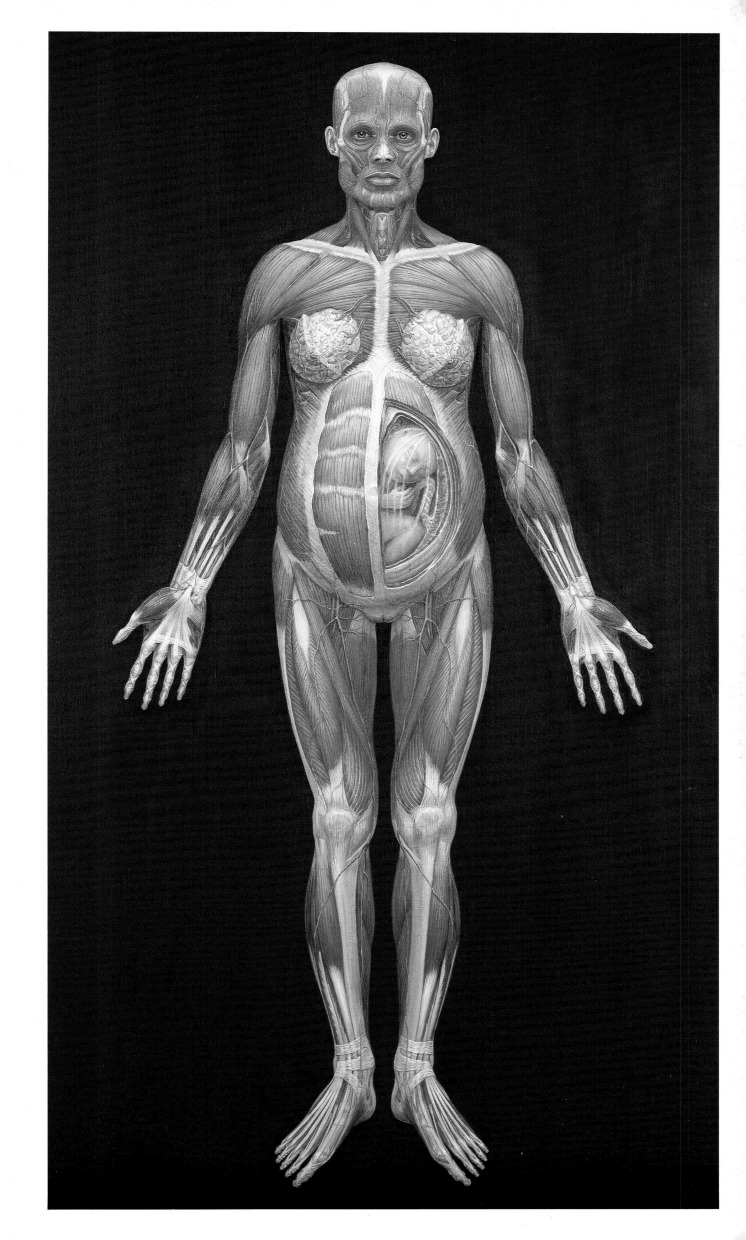

MUSCLE SYSTEM
(PREGNANT WOMAN)
1980, OIL ON LINEN
84 × 46 IN.

◄ MUSCLE SYSTEM
(DETAIL)

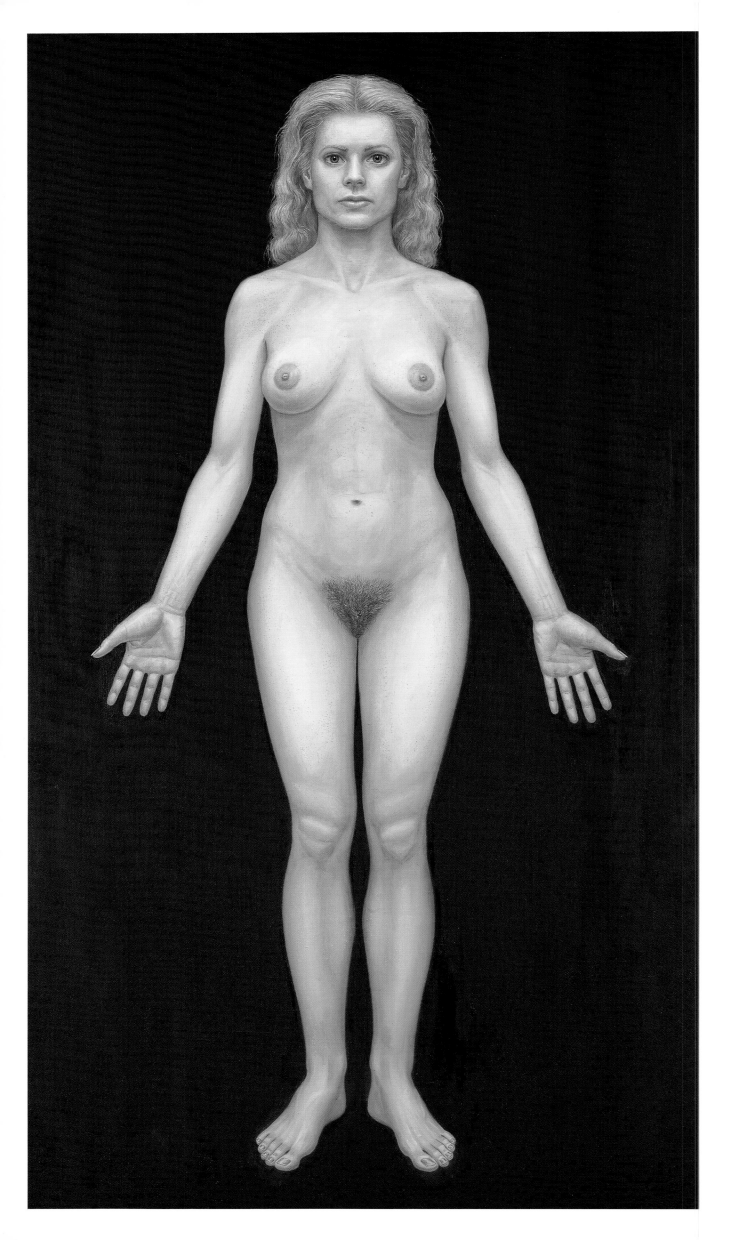

CAUCASIAN WOMAN
1981, OIL ON LINEN
84 × 46 IN.

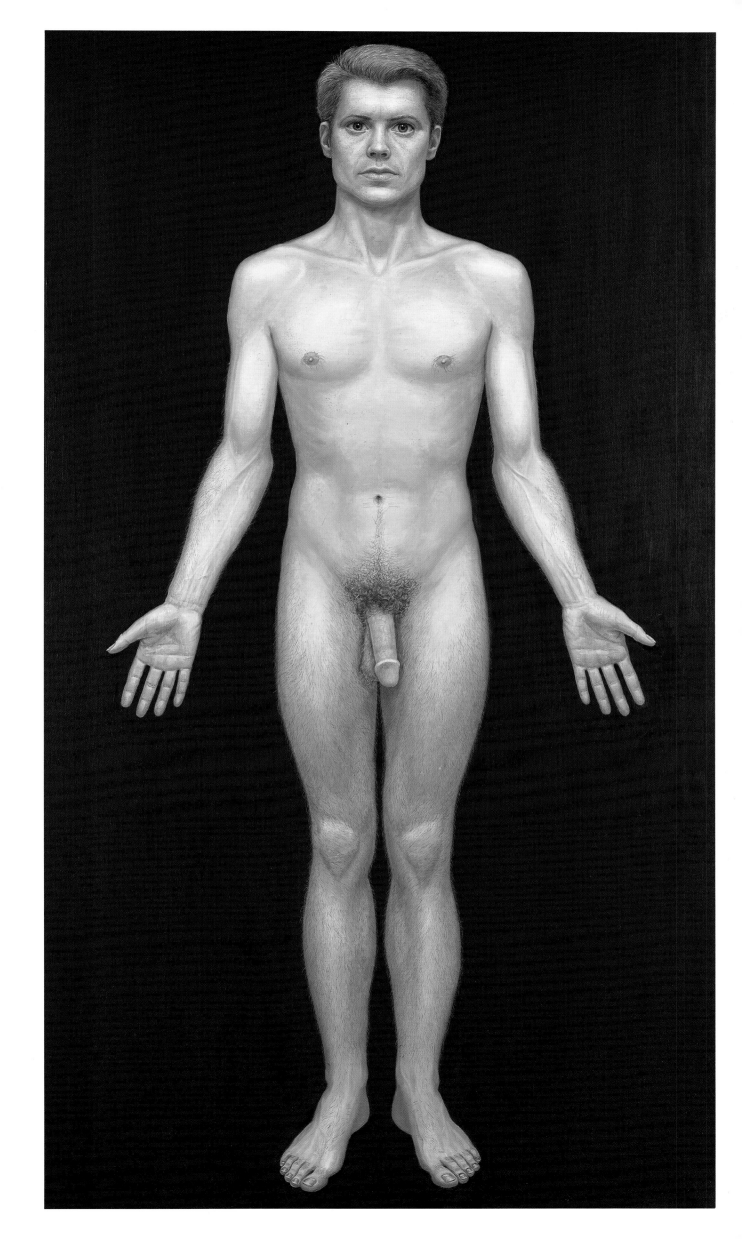

CAUCASIAN MAN
1981, OIL ON LINEN
84 × 46 IN.

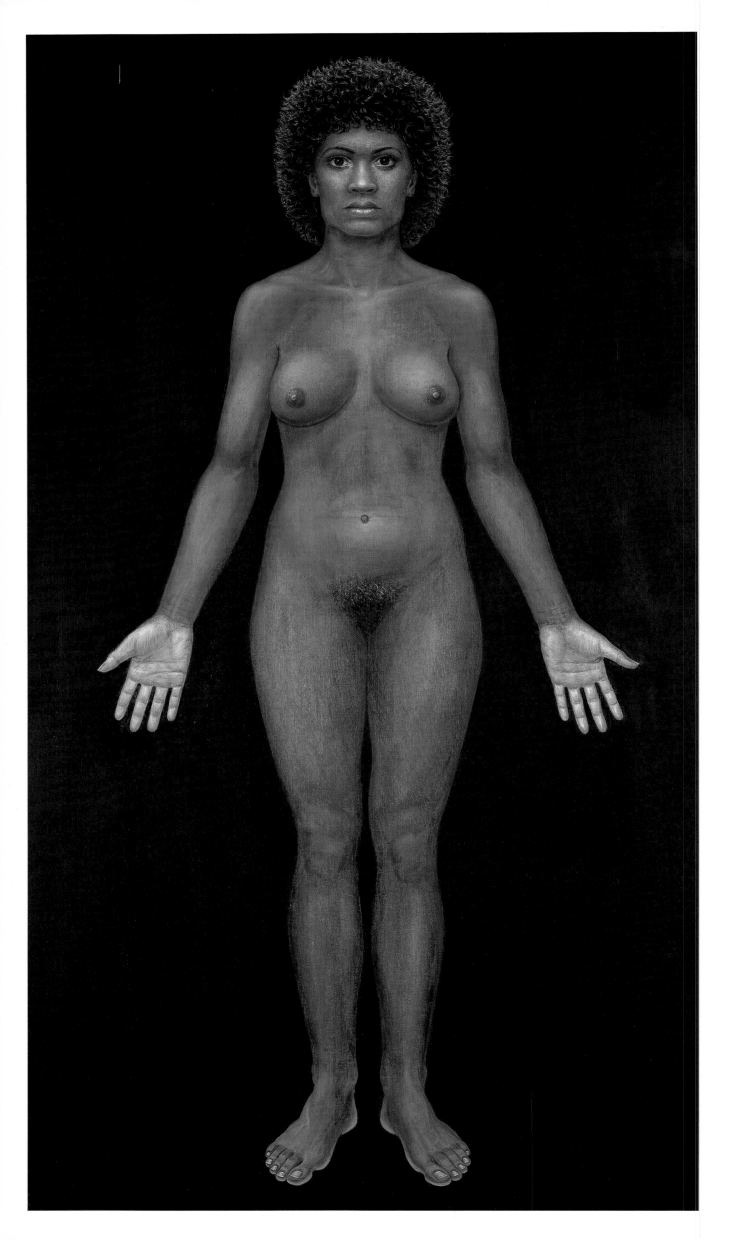

AFRICAN WOMAN
1981, OIL ON LINEN
84 × 46 IN.

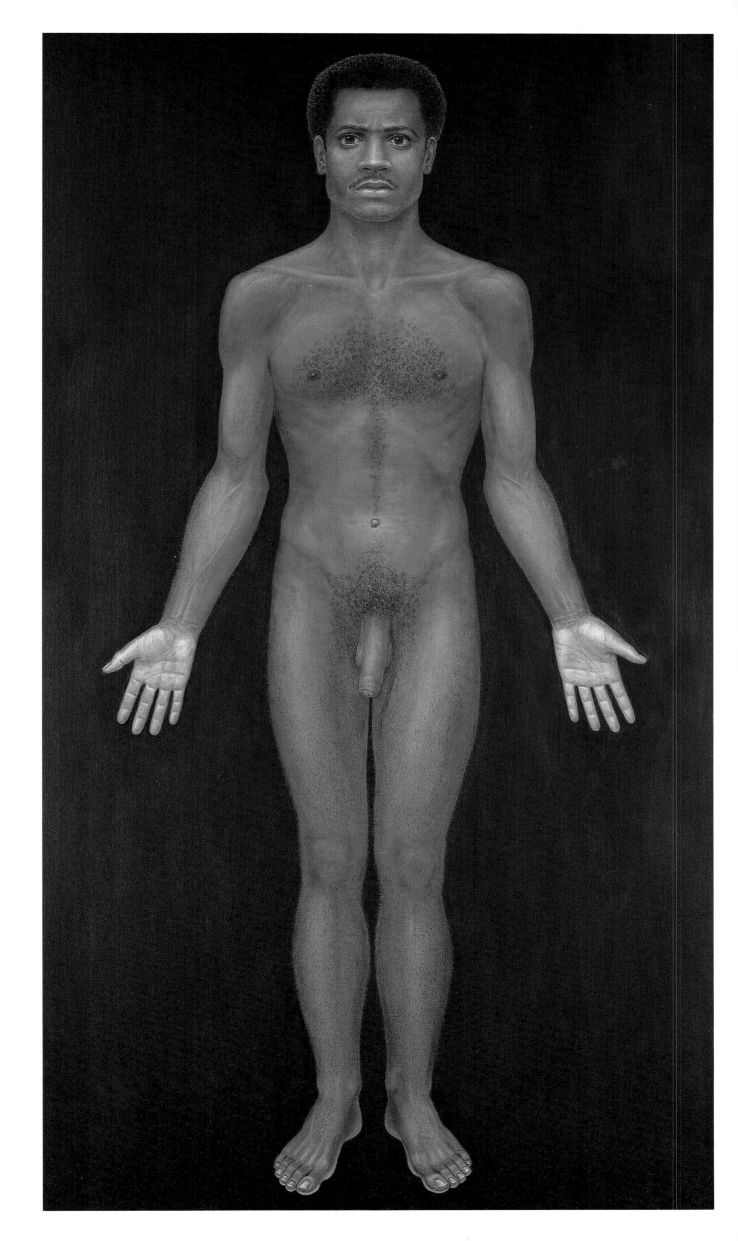

AFRICAN MAN
1981, OIL ON LINEN
84 × 46 IN.

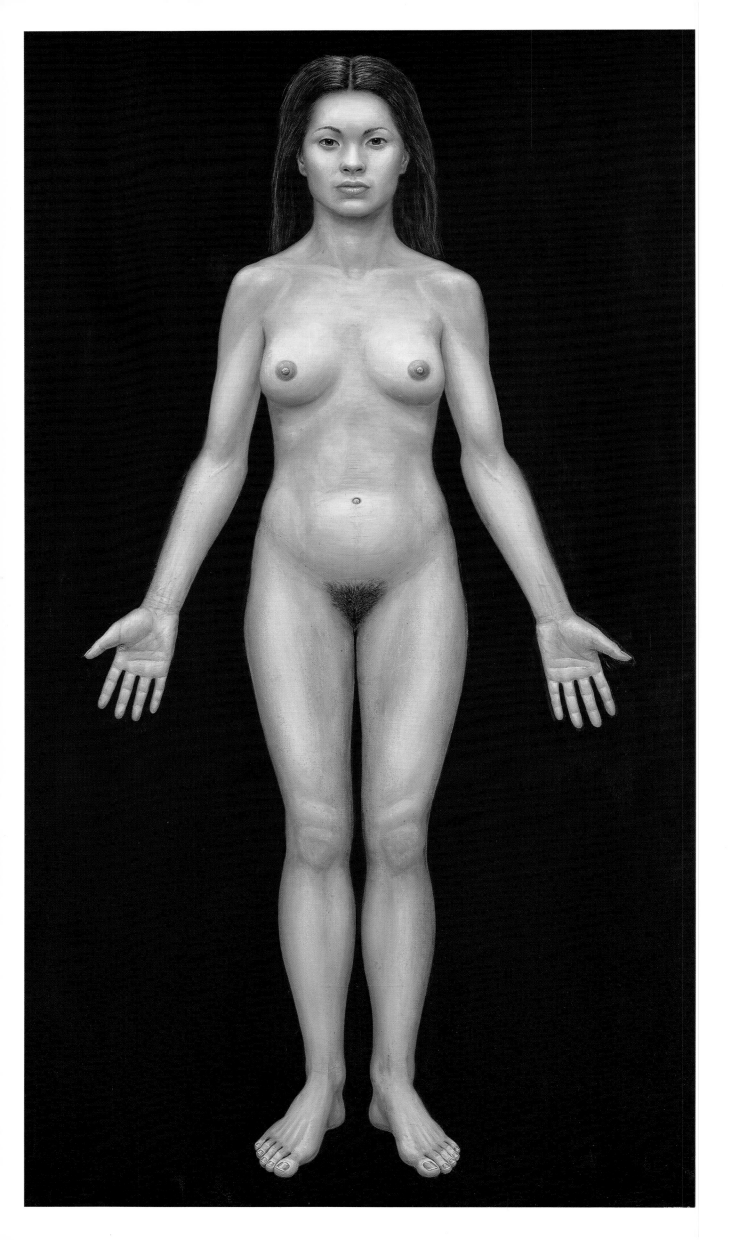

ASIAN WOMAN
1981, OIL ON LINEN
84 × 46 IN.

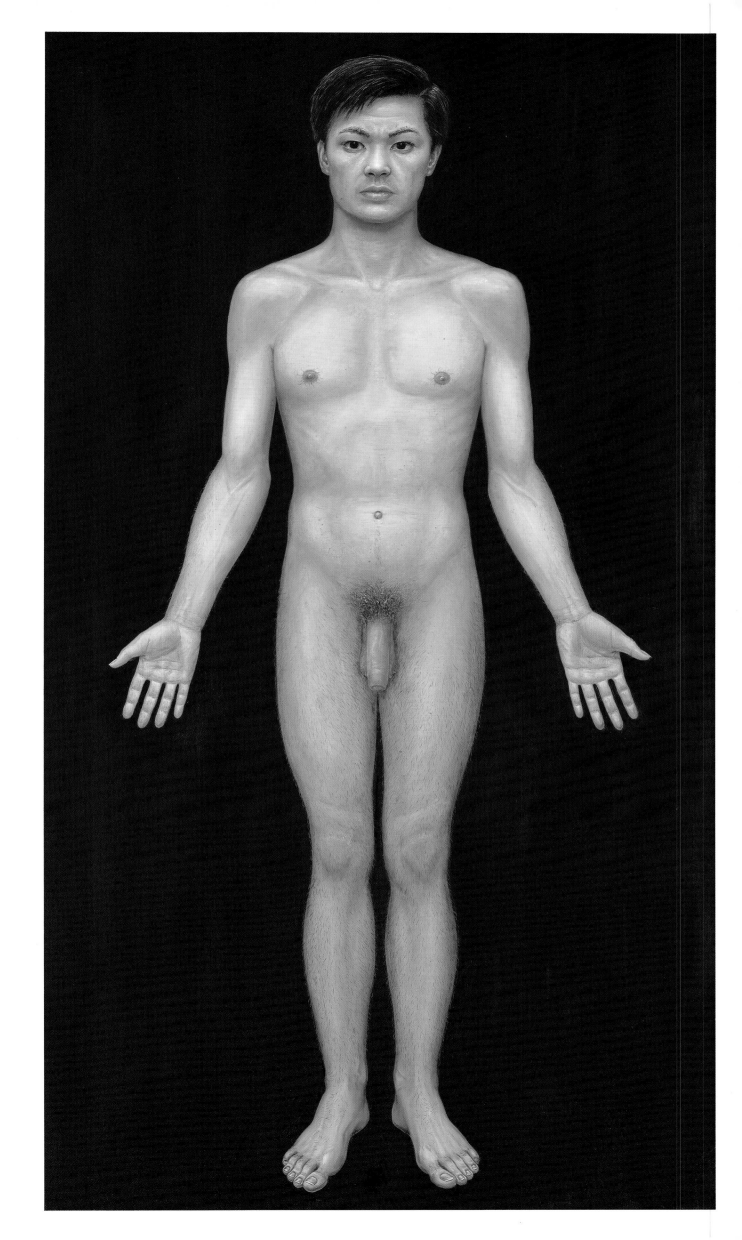

ASIAN MAN
1981–82, OIL ON LINEN
84 × 46 IN.

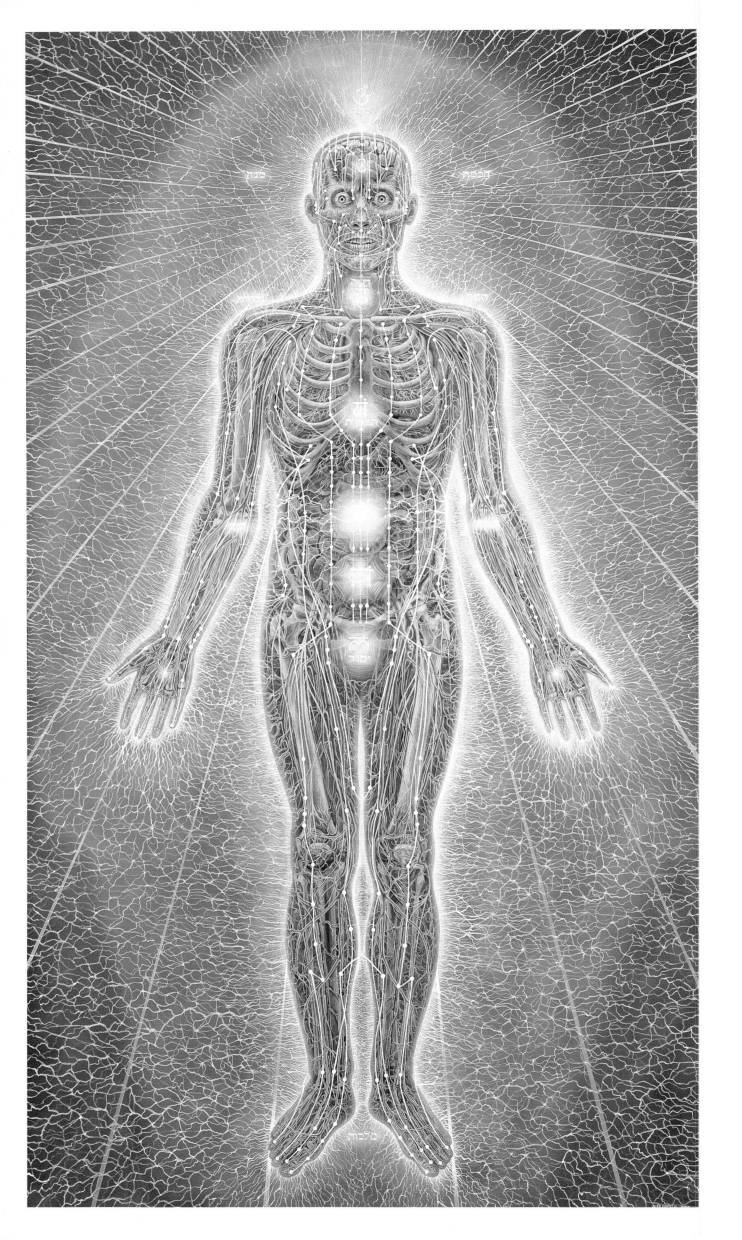

PSYCHIC ENERGY SYSTEM
1980, ACRYLIC ON LINEN
84 × 46 IN.

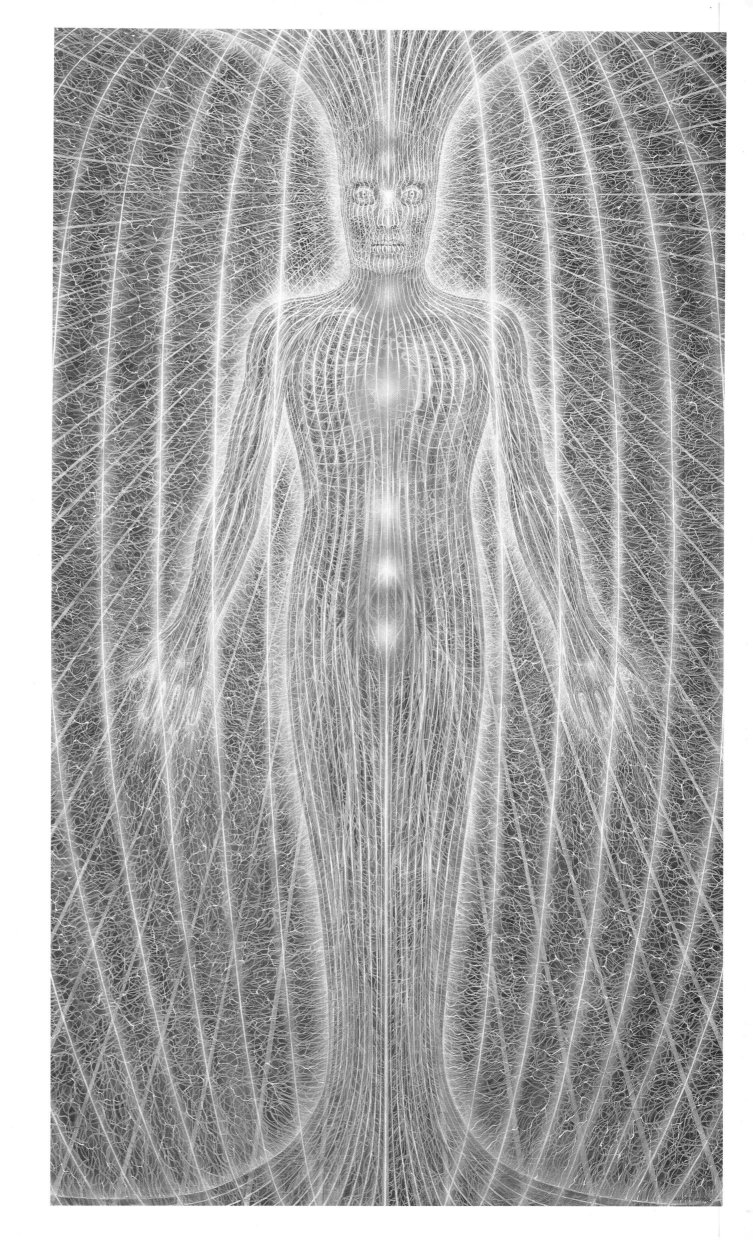

SPIRITUAL ENERGY SYSTEM
1981, ACRYLIC ON CANVAS
84 × 46 IN.

Thine own consciousness, shining, void, and inseparable from the Great Body of Radiance, hath no birth, nor death, and is the Immutable Boundless Light.

Padmasambhava, The Tibetan Book of the Dead

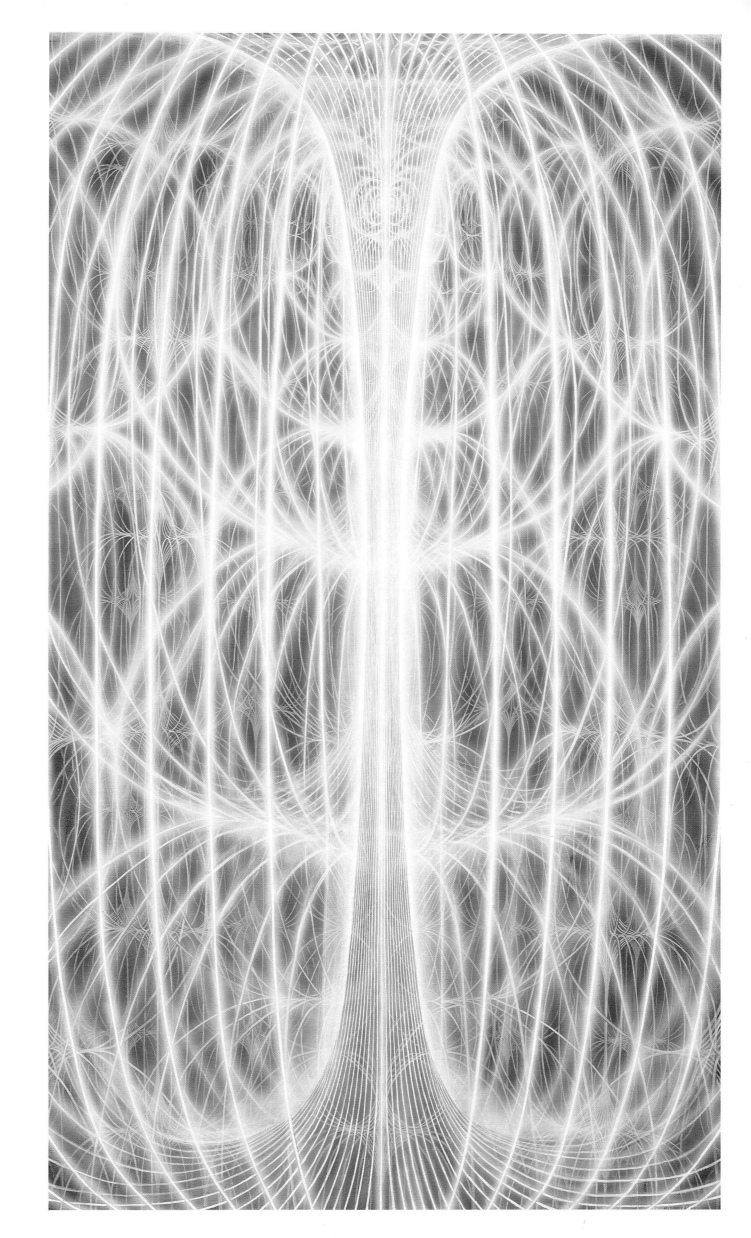

UNIVERSAL MIND LATTICE
1981, ACRYLIC ON CANVAS
84 × 46 IN.

Though words are spoken to explain the Void,
The Void as such can never be expressed.
Though we say, "The Mind is a bright light,"
It is beyond all words and symbols.
Although the mind is void in essence,
All things it embraces and contains.

Tilopa, THE SONG OF MAHAMUDRA

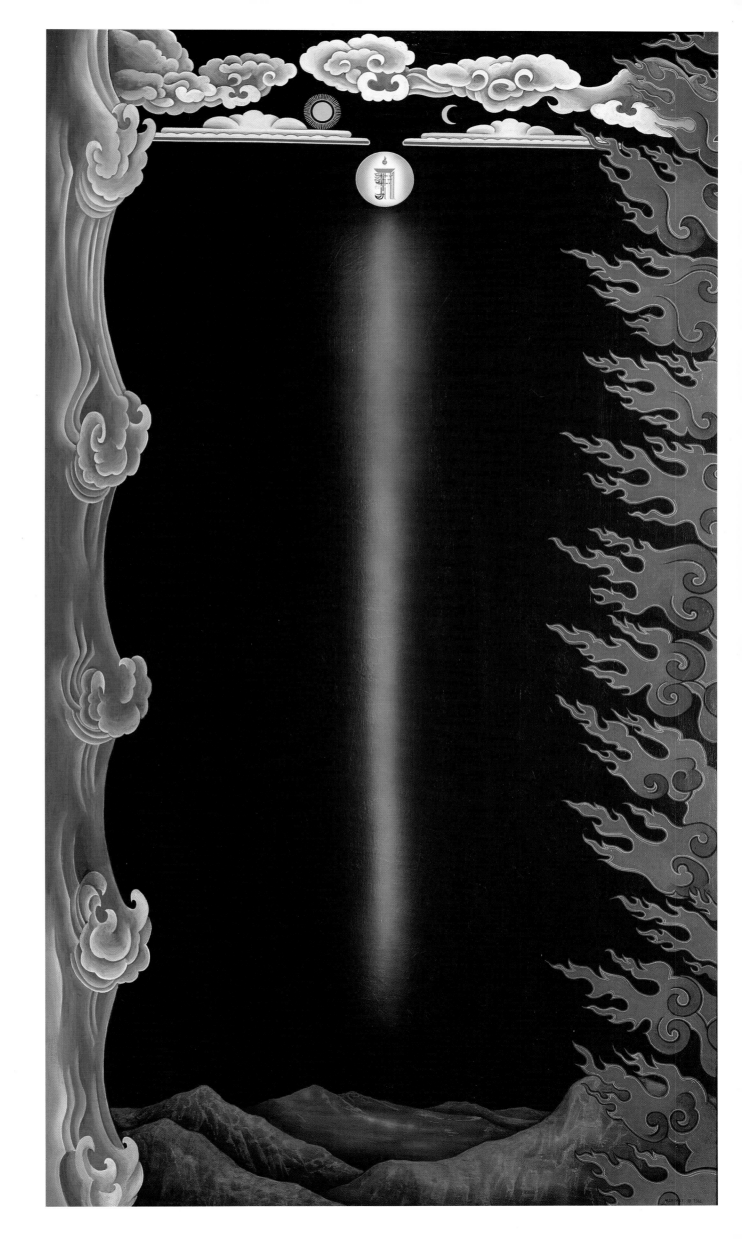

VOID/CLEAR LIGHT
1982, ACRYLIC ON LINEN
84 × 46 IN.

May I be the doctor and the medicine
And may I be the nurse
For all sick beings in the world
Until everyone is healed.

May a rain of food and drink descend
To clear away the pain of thirst and hunger
And during the aeon of famine
May I myself change into food and drink.

May I become an inexhaustible treasure
For those who are poor and destitute;
May I turn into all things they could need
And may these be placed close beside them.

> *Shantideva*, A GUIDE TO THE
> BODHISATTVA'S WAY OF LIFE

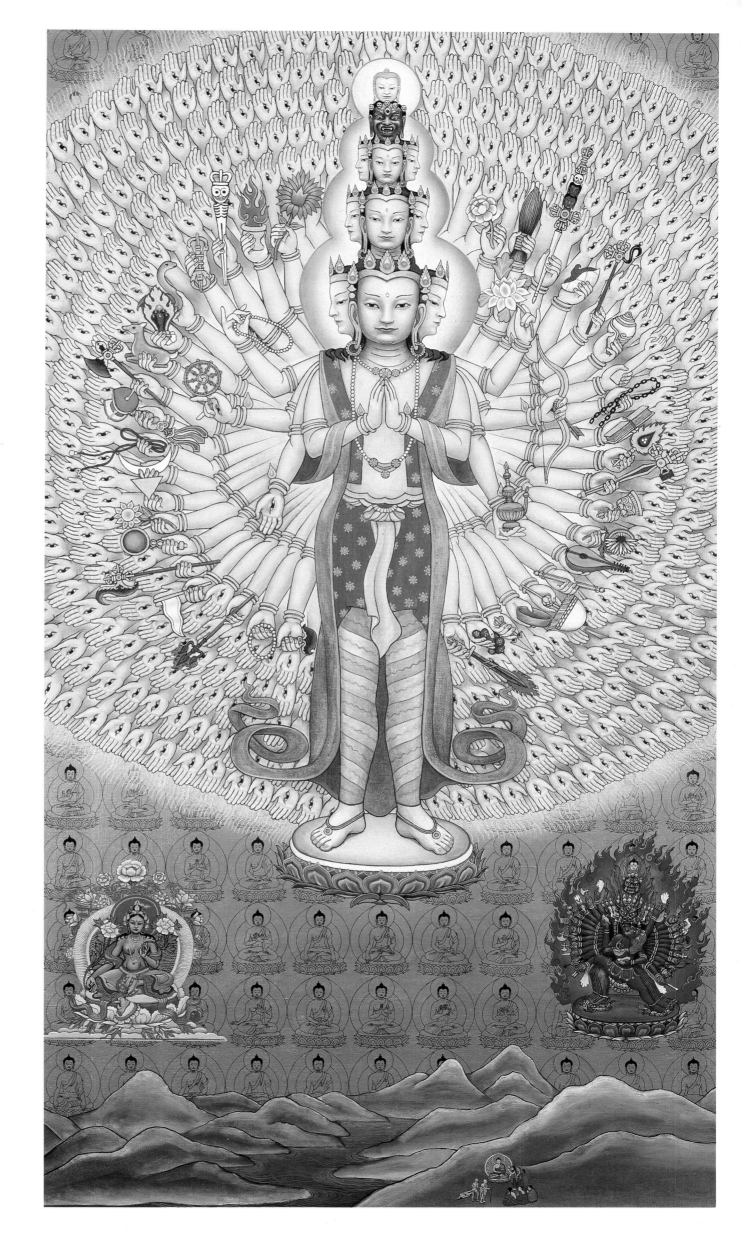

AVALOKITESVARA
1982–83, ACRYLIC ON LINEN
84 × 46 IN.

◄ AVALOKITESVARA
(DETAIL)

Jesus said, "When you make the two one, and when you make the inside like the outside and the outside like the inside, and the above like the below, and when you make the male and the female one and the same . . . then you will enter the Kingdom of God."

GOSPEL OF THOMAS

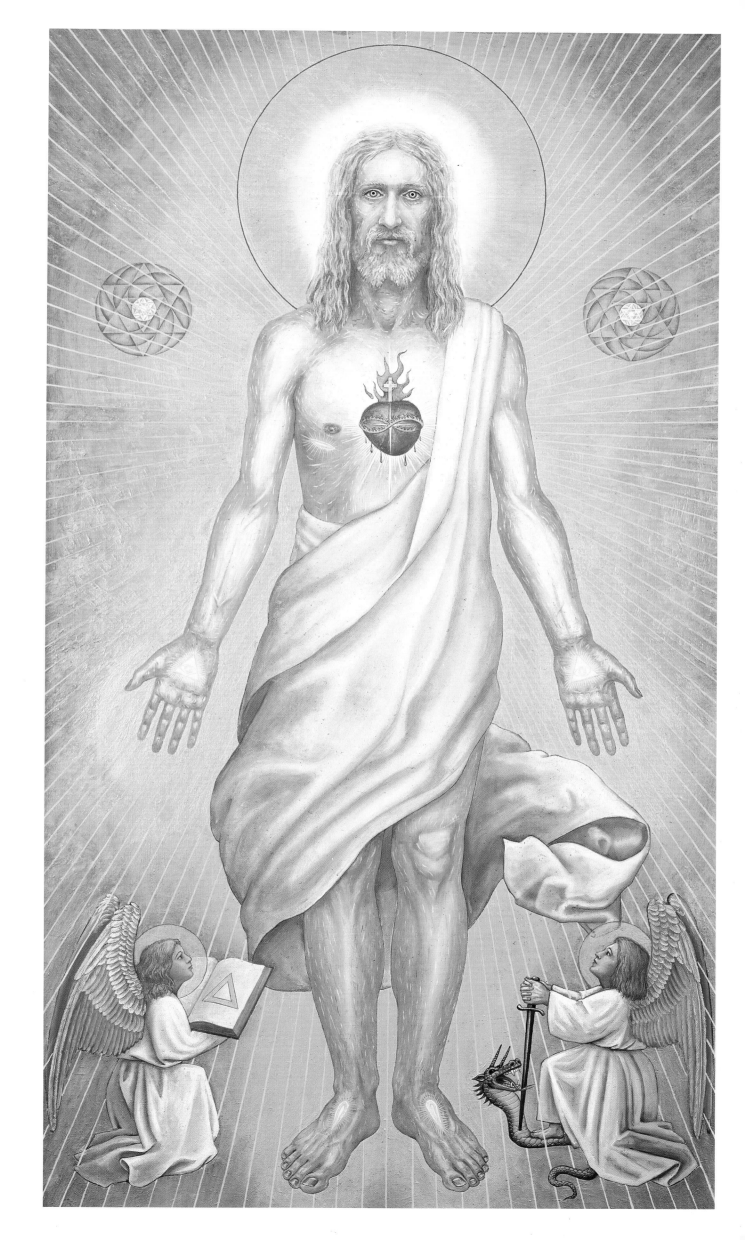

CHRIST
1982–85, OIL ON LINEN
84 × 46 IN.

◀ CHRIST
(DETAIL)

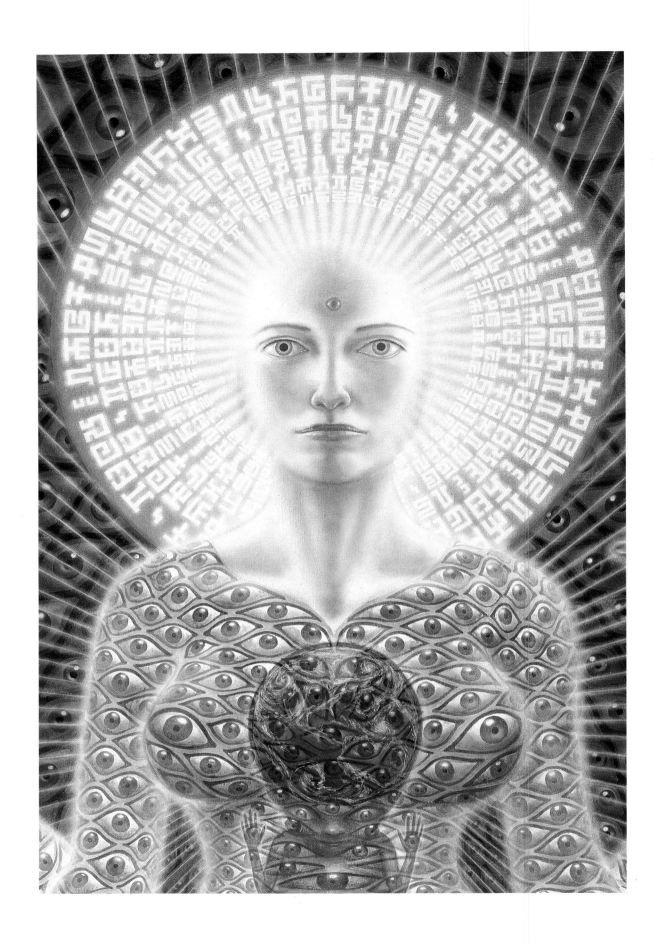

I am the first and the last. I am the honored one and the scorned one.
I am the whore, and the holy one. I am the wife and the virgin.
I am the mother and the daughter. . . . I am she whose wedding is great,
and I have not taken a husband. . . . I am knowledge, and ignorance.

THUNDER, PERFECT MIND, *Gnostic poem, 100 A.D.*

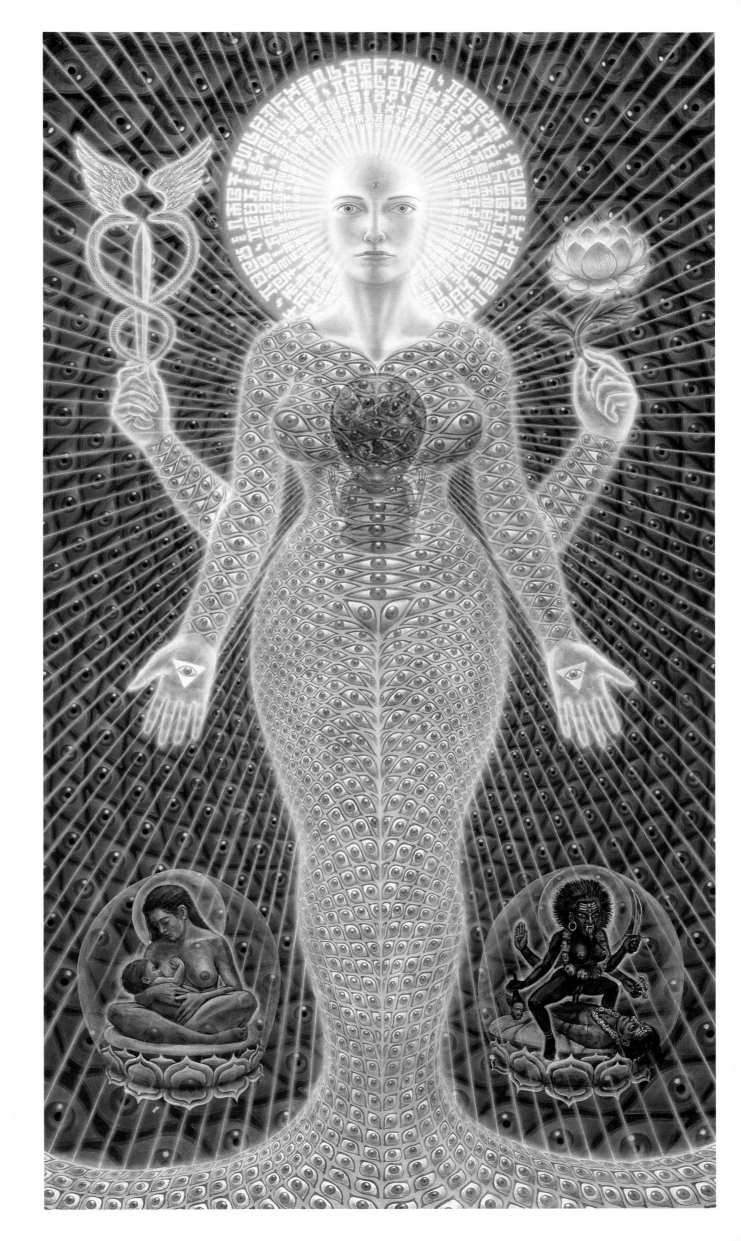

SOPHIA
1989, ACRYLIC ON CANVAS
84 × 46 IN.

◄ SOPHIA
(DETAIL)

There is a Light that shines beyond all things on earth, beyond us all, beyond the heavens, beyond the highest, the very highest heavens. This is the Light that shines in our heart.

CHANDOGYA UPANISHAD

SPIRITUAL WORLD
1985–86, SANDBLASTED MIRROR
WITH ILLUMINATION
84 × 46 IN.

◄ SPIRITUAL WORLD
(DETAIL)

PROGRESS OF THE SOUL

The soul incarnates to perform certain tasks, and to learn certain lessons. Everyone has a soul purpose in life and unique gifts to fulfill that purpose. The reality of a soul purpose is sometimes clear in the transformative experiences of life such as love, work, and family relationships. The awareness of one's own mortality and of threats to the collective life of the planet provides a deeper perspective for fully and self-consciously appreciating the gift of life, and the purpose of the soul.

The selection of paintings that follows came after the *Sacred Mirrors*. Although not painted as a series, they have been arranged to imply an evolving self-awareness. The physical, mortal aspect of our existence is presented in a metaphysical framework that acknowledges the psyche, soul, and spirit as well as the interconnectedness of all beings. These are transcultural, hybrid, mystical images. I believe there is a superconscious realm of archetypes from which all sacred imagery arises. The job of the visionary artist is to experience the higher spiritual states and to bring this experience—in the form of energy and imagery—to his or her art. The intention behind the work has been to make visible the immanent divine, to point to the transcendent divine, to encourage healing forces and actions, and return one to the Great Mystery: Who are we?; Why are we here?; and Where are we going?

Praying *is a portrait revealing a sun in the heart and mind. From the inner light in the center of the brain, a halo emanates and surrounds the head. The halo is inscribed with signs of contemplation from six different paths: the symbols of Yin and Yang from Taoism; a description of the magnitude of Brahman from Hinduism; the watchword of the Jewish faith, "Hear Oh Israel, the Lord our God, the Lord is One"; the Tibetan Buddhist mantra, "Om Mani Padme Hum," a prayer for the unfolding of the mind of enlightenment; Christ's words of the "Lord's Prayer" in Latin; and a description of Allah along with the Islamic prayer, "There is no God but God, and Muhammad is his messenger." I have attempted to present the spiritual core of light which transcends, unites, and manifests in the various religious paths.*

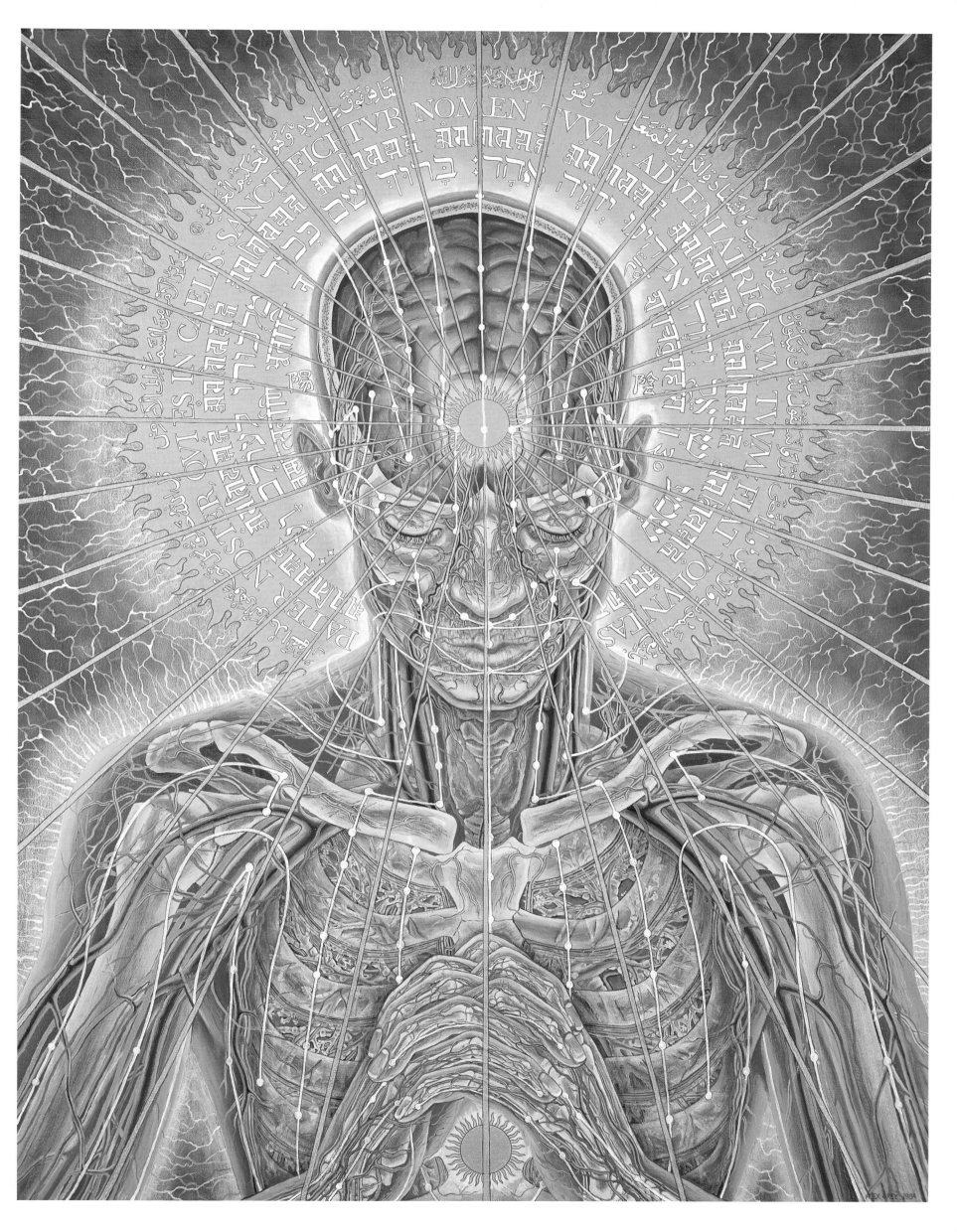

KISSING
1983, OIL ON LINEN
66 × 44 IN.

In this image I have used the golden flame to symbolize consciousness and spirit. There are two infinity bands of golden flames looping through the hearts and minds of the couple, suggesting the bond of infinite love which transcends the impermanence of the flesh.

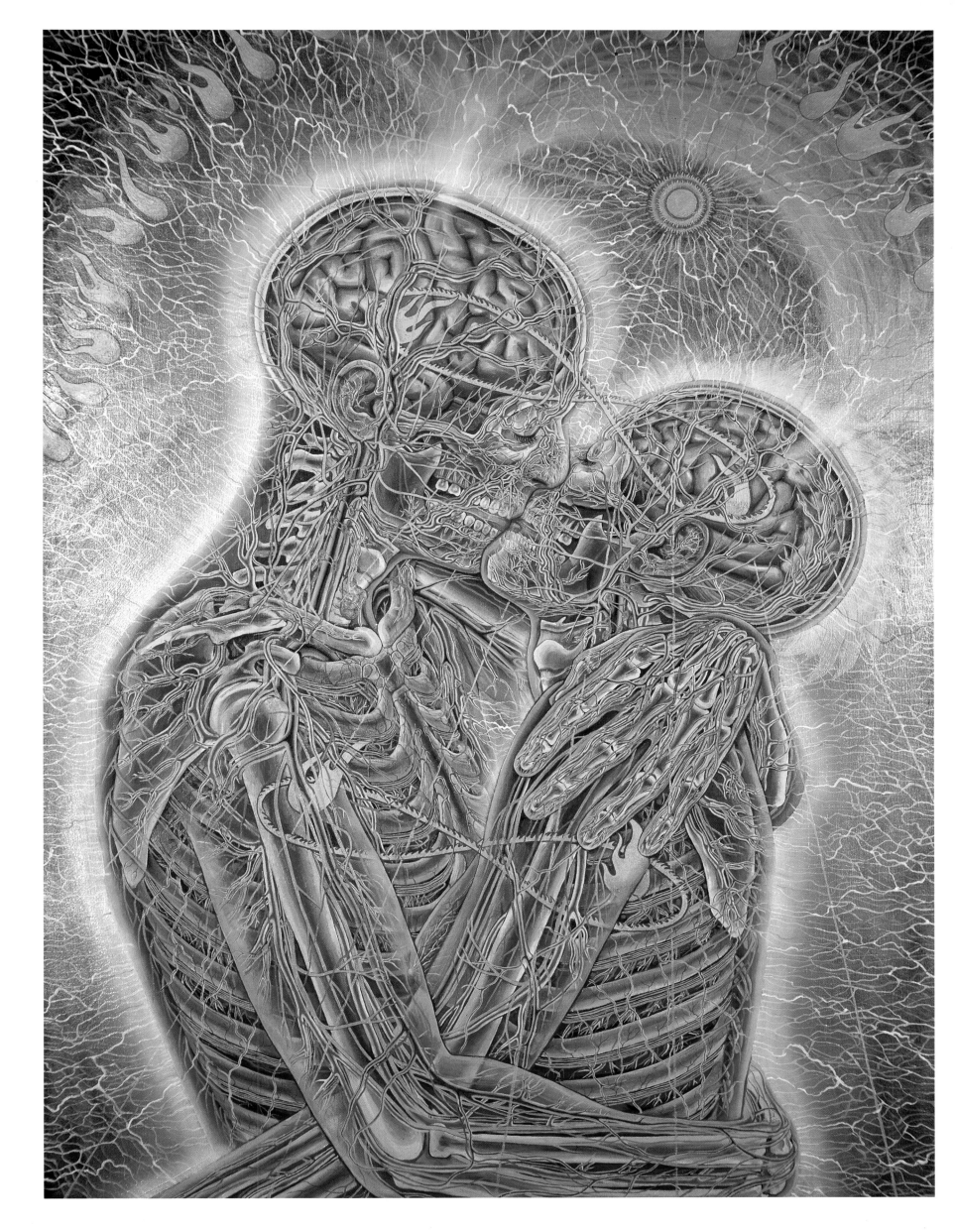

COPULATING
1984, OIL ON LINEN
75 × 96 IN.

A purifying fireball of passion surrounds the embracing couple, welding them together. Eros implies the divine will for human surrender in love to create new life. Astral energy vortexes stream out from the lovers, alerting souls of a possible opportunity for incarnation. The couple is observed by the watchful eyes of birth and death. Infinite love bands flow through the cosmic superimposition of the two polar life energy streams. In the center of the couple a crystalline Shri yantra, one of the most ancient tantric symbols, signifies the dynamic balance and interpenetration of opposites.

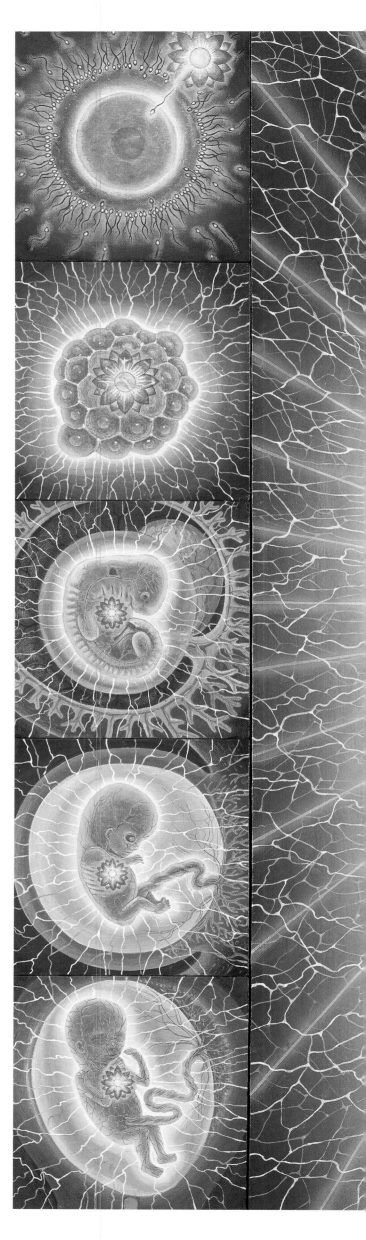

PREGNANCY
1988–89, OIL ON LINEN
50 × 56 IN.

The soul incarnates by becoming karmically connected with the parents and choosing their sperm and egg. The soul oversees the biomolecular construction of a new body, and barring damaging influences, the new body will be nearly perfect. The embryological bloom of creation, starting as a single-celled zygote, miraculously unfolds into trillions of cells working harmoniously in the various systems of the body. This is a time of radical transformation for the incarnating soul, as well as for the new parents. This painting was done while Allyson was pregnant with our daughter, Zena Lotus Grey.

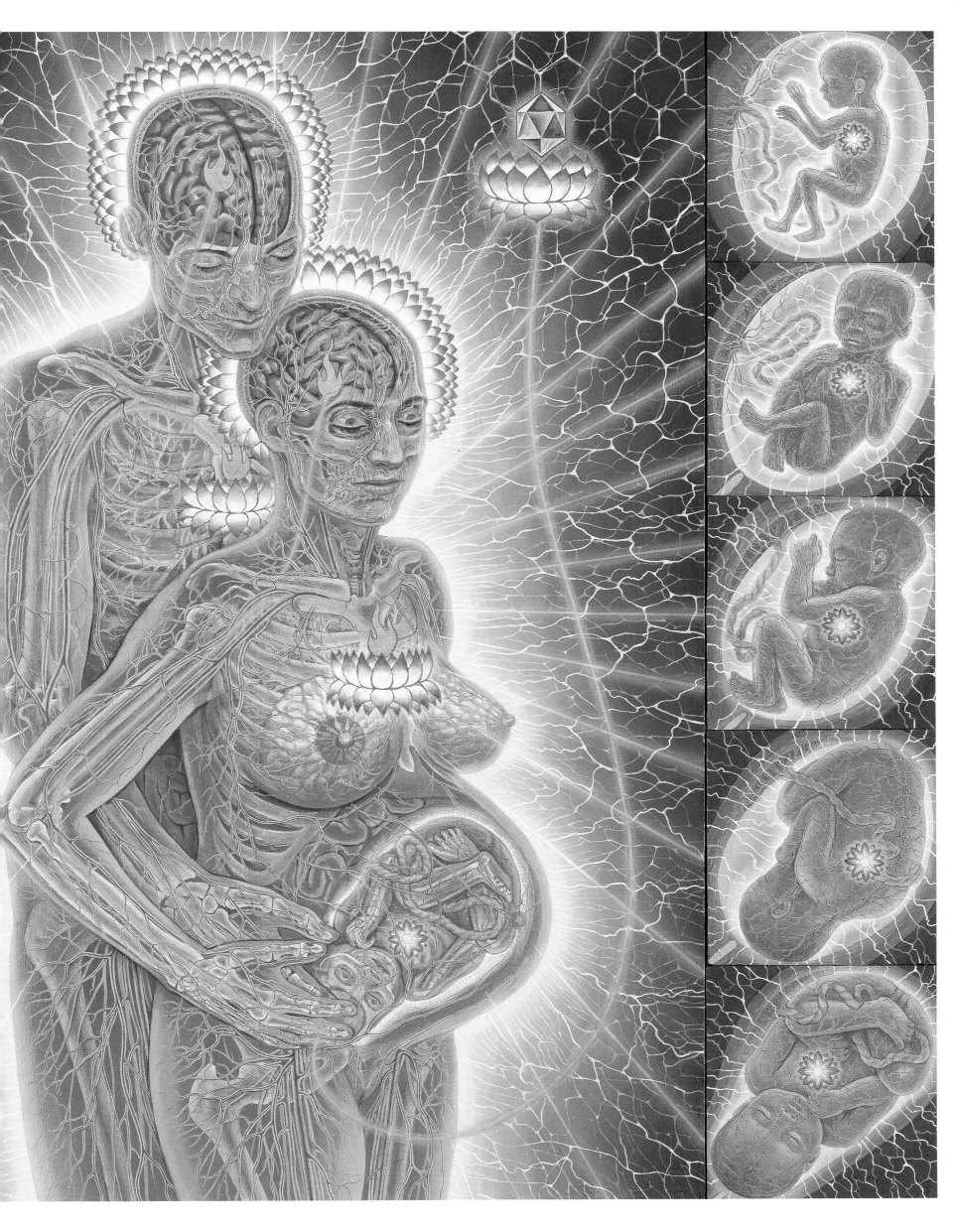

NURSING
1985, OIL ON LINEN
40 × 30 IN.

The bonding of mother and child is a miraculous outpouring of unobstructed love channeled through the mortal coil. Nursing is the physical bond of nourishment—mother is the first meal, she is the key to life. Between mother and child, there are also bio-electromagnetic bonds, emotional and psychic bondings, and ultimately the spiritual bond that brought them together.

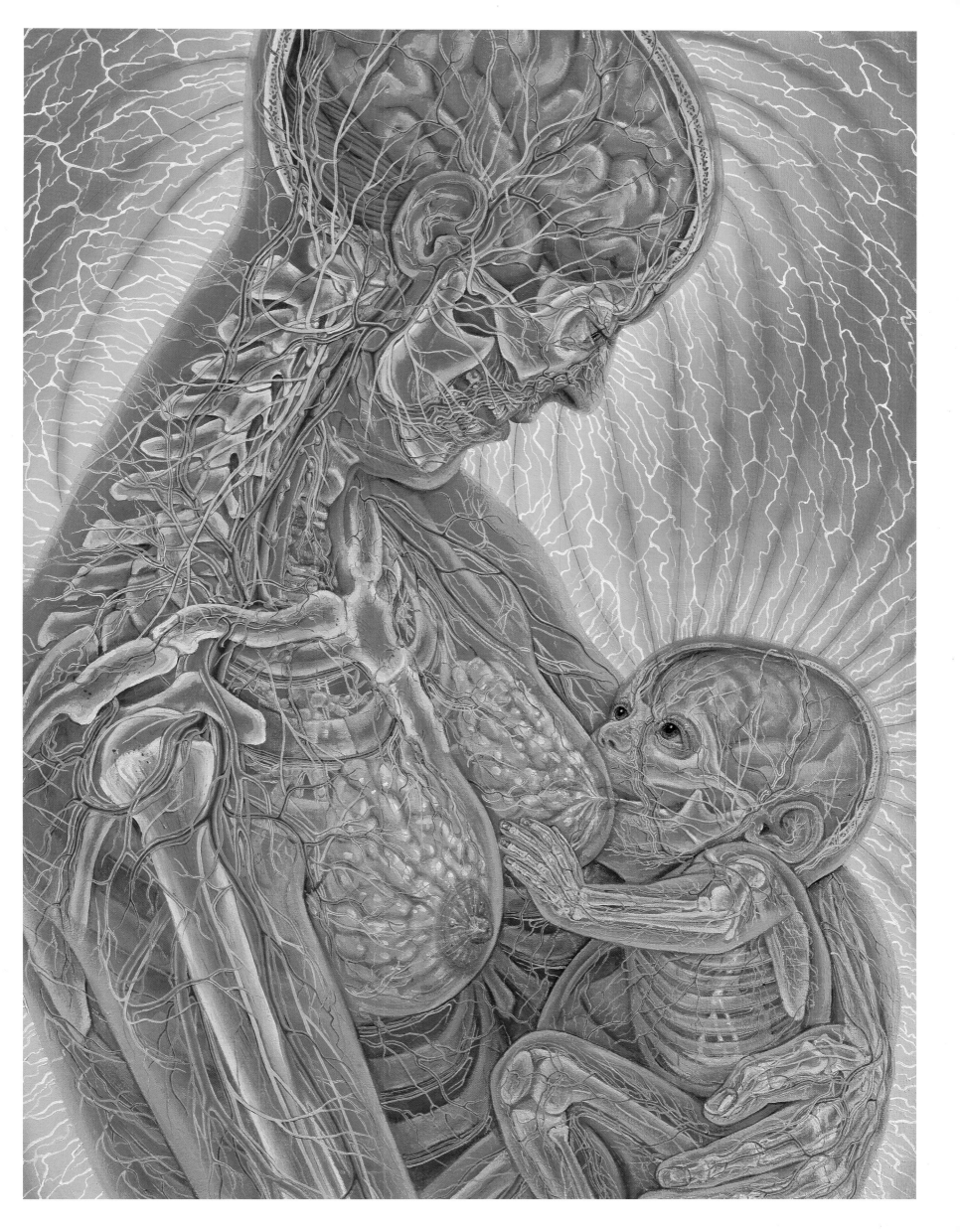

There is always hope in a new family. They face an uncertain future but they are grounded in pure devotional love. Their love binds them together in a braid of souls.

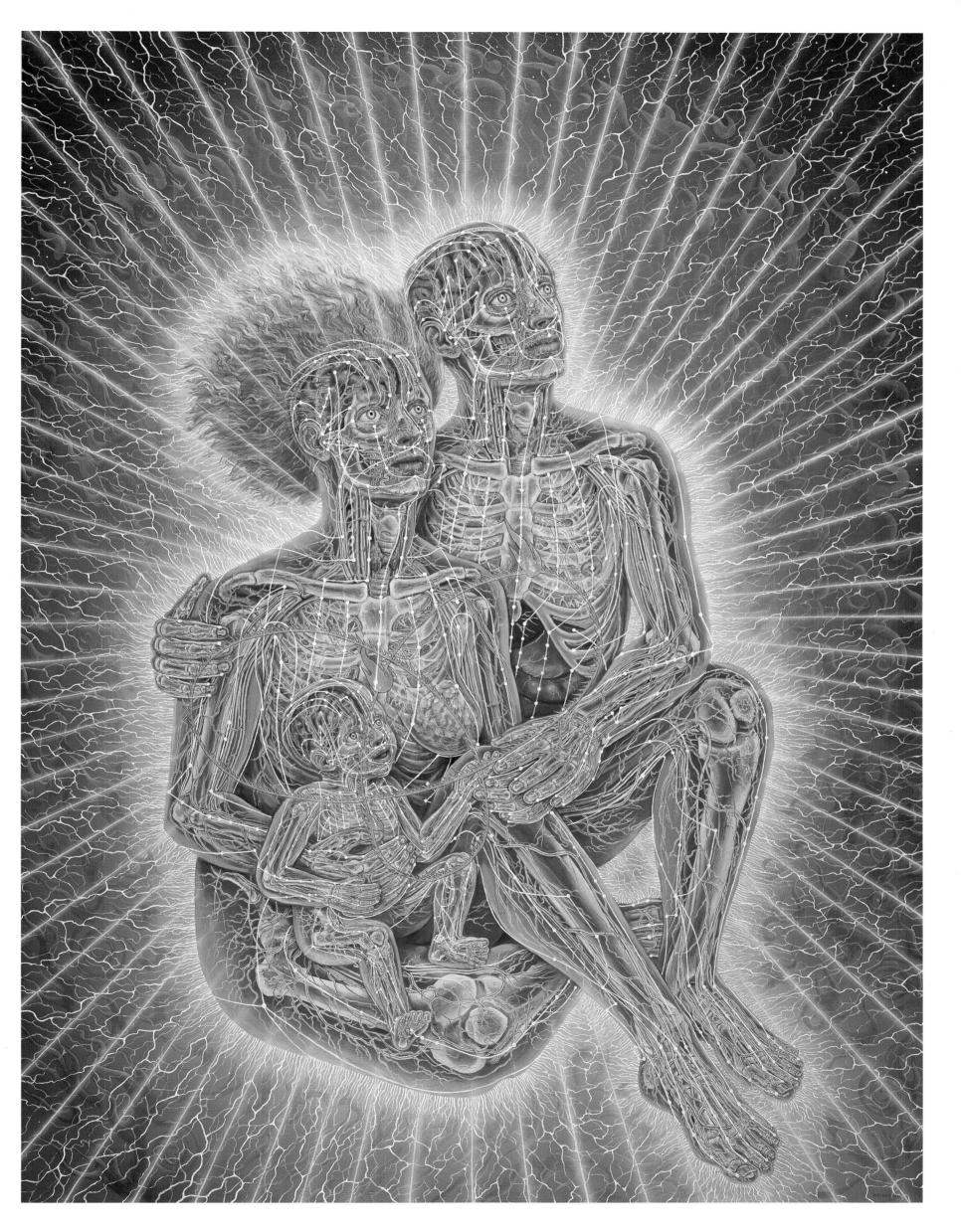

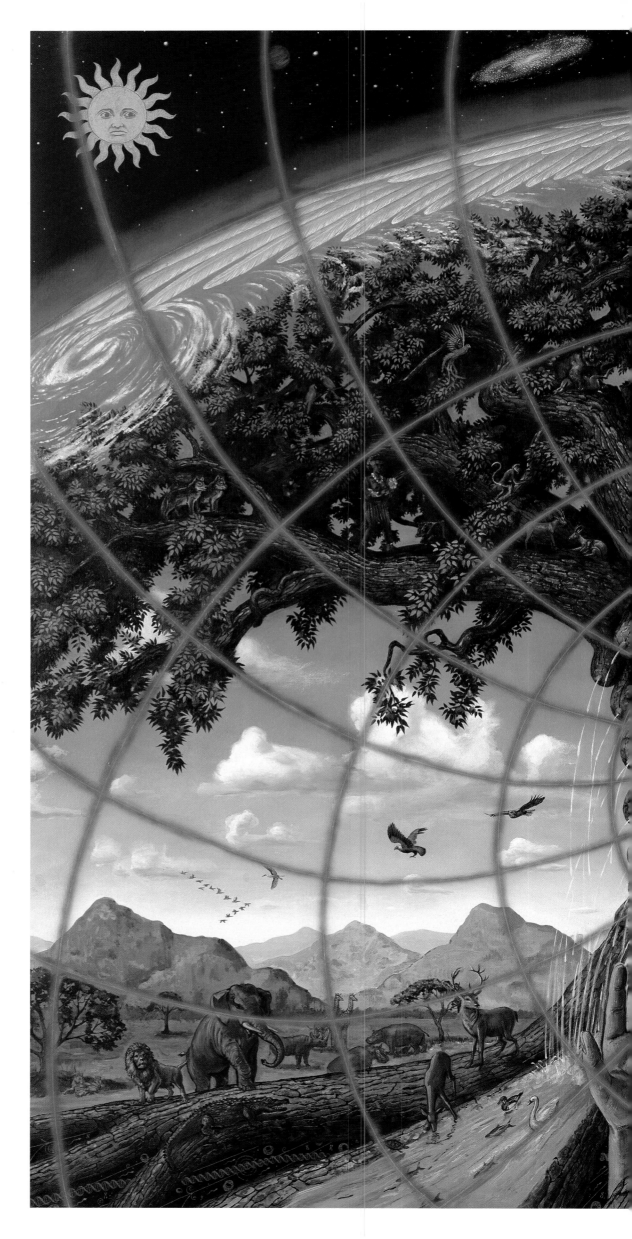

GAIA
1989, OIL ON LINEN
96 × 144 IN.

The day after our daughter, Zena, was born I had a vision of Gaia, the World Soul. Gaia was the tree of life or web of life with her root in the subatomic, atomic, molecular, and cellular levels of matter (mater/mother) reaching upward through the oceans, stones, soil, grass, forests, mountains, lakes, rivers, air, and atmosphere to nurture all plants and creatures. A natural cycle of birth, sustenance, and death was woven into the tapestry of Nature. Gaia continuously gave birth to life through the love energy in her heart. The future generations of humanity were symbolized by a human mother nursing in Gaia's cave.

Gaia's body was being ravaged and destroyed by man, reflecting the present crisis in the environment. A diseased and demonic phallus had erected structures all over the earth to suck dry Gaia's milk and turn it into power and money. The wasteland of a disposable culture was piled high and was seeping into the microgenetic pool causing diseases and defects in the Great Chain of Life.

Emerging also from that microgenetic level—but on the side of Nature— was an evolutionary alarm represented by a large "seeing" hand which catalyzed the collective will of the people, enabling them to see, with eyes of unobstructed vision, the actions necessary to stop the destruction of the world soul.

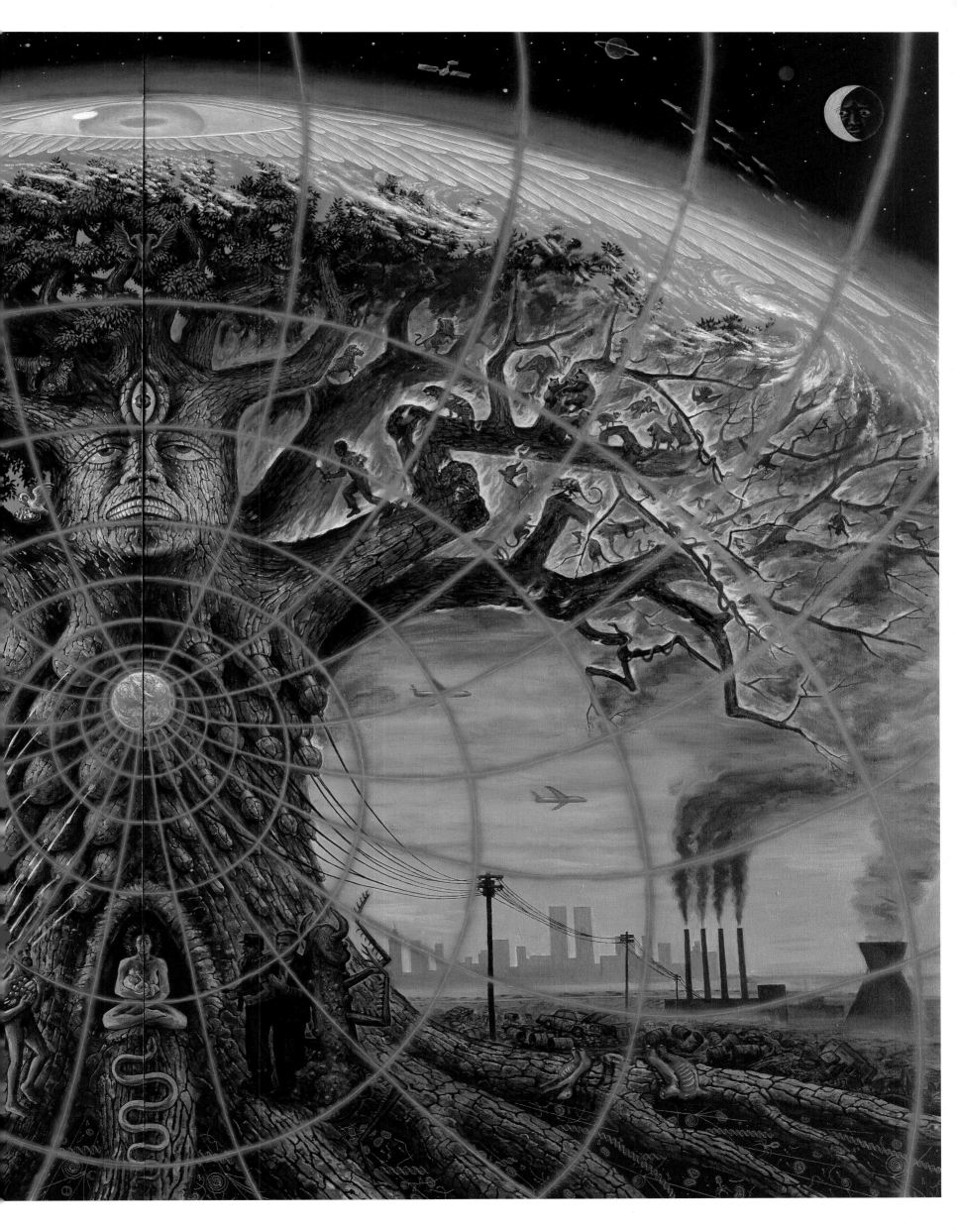

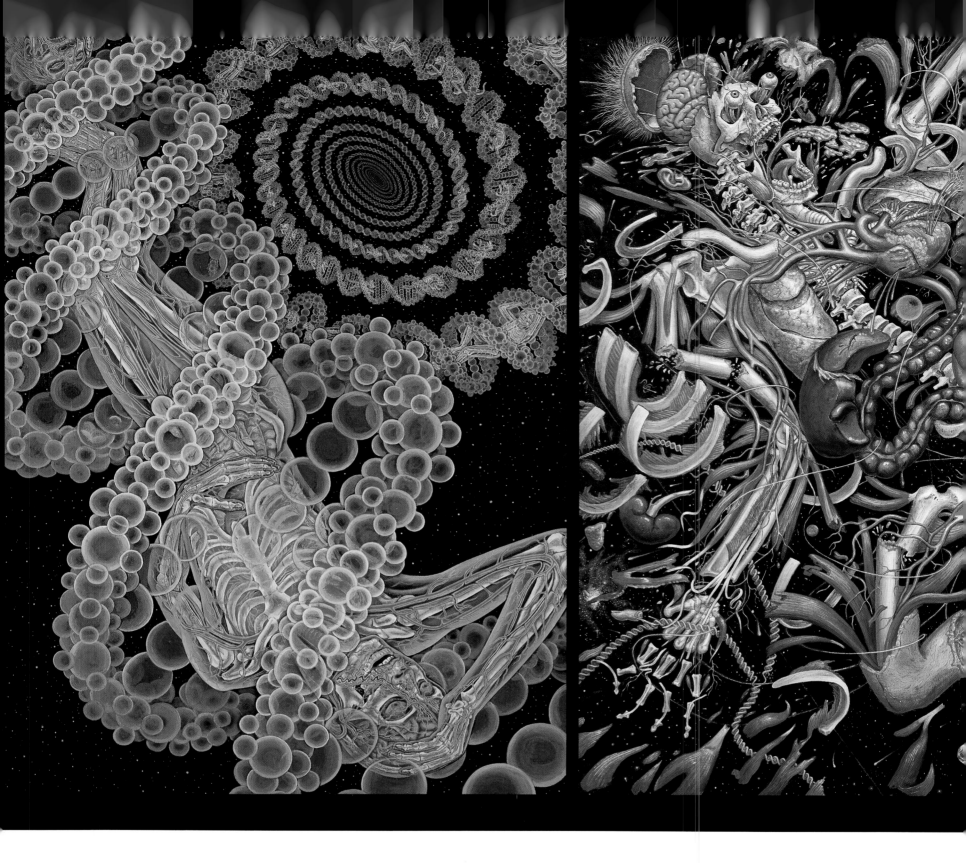

JOURNEY OF THE
WOUNDED HEALER
(TRIPTYCH)
1984–85, OIL ON LINEN
90 × 216 IN.

In the first panel we see the self trapped in a dizzying vortex of evolutionary descent, paralleling the hallucinatory descent of the initiate shaman into the underworld or realm of the dead. The prisoner yearns for freedom and becomes sick with the materialist limitations of his genetic chains represented by entrapment in a spiralling DNA molecule.

In the central panel the self explodes and dismembers itself in the mysterium tremendum, a powerful confrontation with forces on all levels of reality: subatomic, cellular, planetary, galactic, psychical, spiritual. The energy which animates the All, the force of God, erupts through the embodied self and destroys identification with the sickly contracted ego, opening the self to

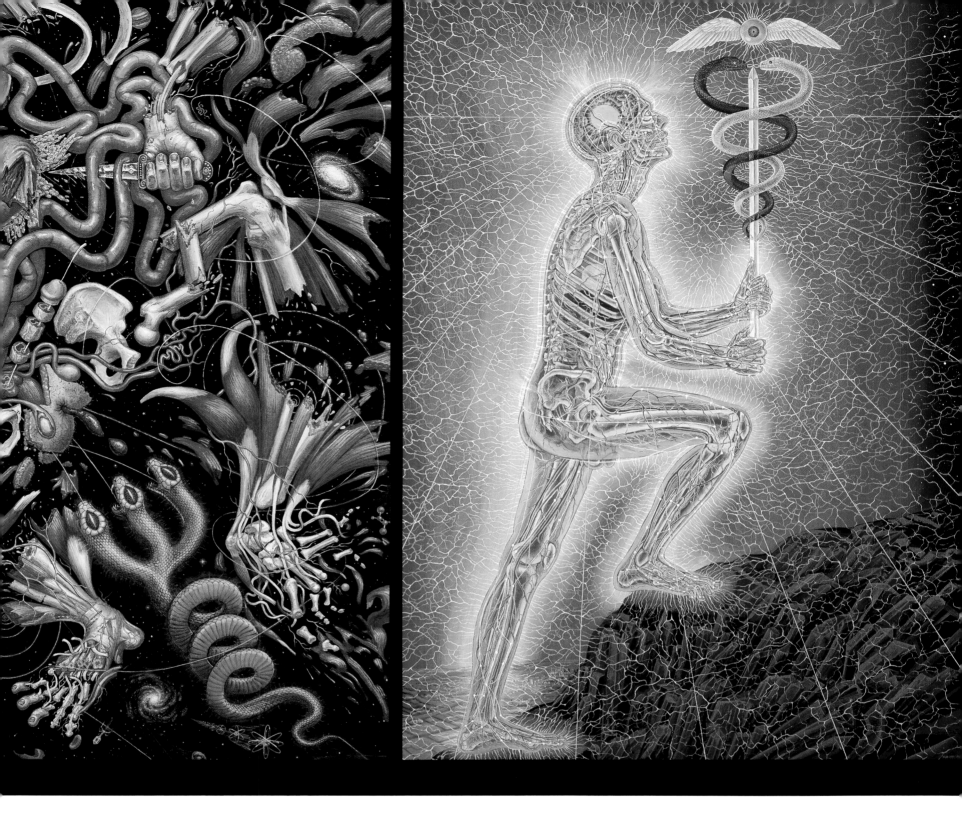

merge with new powers. An alchemical serpent power with three heads (representing body, mind, and spirit) weaves an integrating and transmuting energy which binds together the new self.

In the final panel the reintegrated man ascends into the middle and upper worlds, released from the psychic bonds of materialist entrapment and tapped into the light which beams from the mind and heart. As a healer, he wields a crystalline hermetic caduceus with the balanced serpent powers of the unconscious and winged vision of the superconscious. The healer/scientist/artist ascends the crystal mountain of the higher self, a self empowered by the responsibility for healing the future.

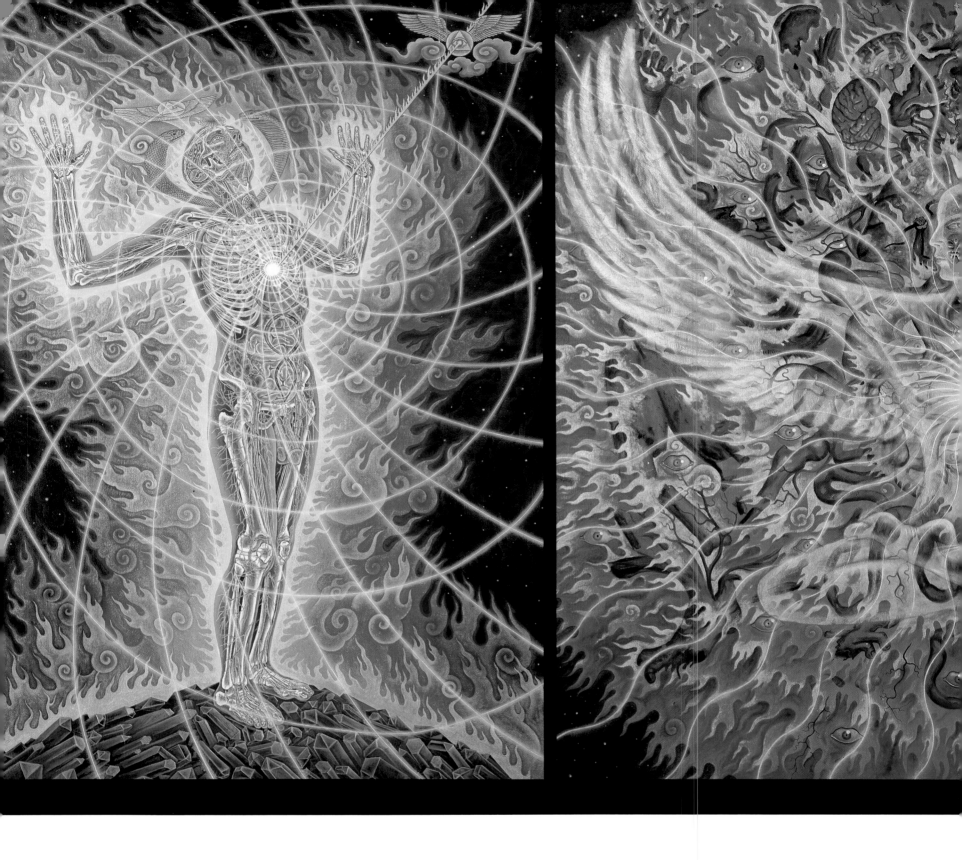

HOLY FIRE
(TRIPTYCH)
1986–87, OIL ON LINEN
90 × 216 IN.

The soul-searching pilgrim arrives on the mountain top, and his kundalini energy, the serpent power, begins to ascend within him. The caduceus or healing staff is internalized. The eye of God in the form of an angelic presence channels heart-opening flames of divine grace into his center, sending his body/mind into a state of God intoxication and mystical shock.

Overloaded by ecstasy and the holy fire of God consciousness, the pilgrim's bodily identity bursts open and is consumed in the transcendental Sun. His dead phallus unites with Kali, the Dark Mother of Time, Birth, and Destruction, in a tantric purification rite. The

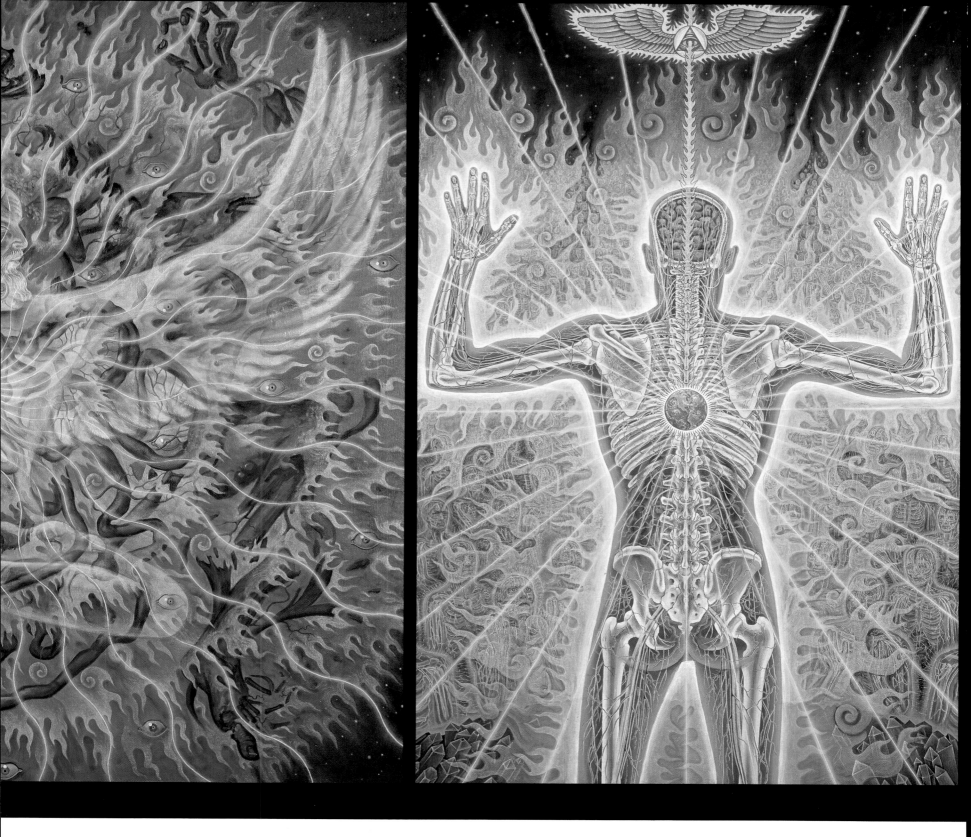

Dark Mother reveals the spiritual core
of the pilgrim as a hermaphroditic di-
vine mutant with clarified nondual
awareness, a soul bird, an angel or
phoenix bestowing gift waves from an
open heart.

 The hero is now renewed and comes
down from the mountain to address the
people. The people are aspects of him-
self—reflecting all the moods from
anger and doubt to elation and epi-
phany. The hero has taken the whole
earth into his heart as his devotional
center. The New Man speaks and acts
out of a new alignment and balance of
heaven and earth in order to heal the
people and the planet.

HOLY FIRE
(DETAIL)
OVERLEAF

DEITIES AND DEMONS
DRINKING FROM
THE MILKY POOL
1987, ACRYLIC ON LINEN
60 × 60 IN.

I had a vision of the group soul of humanity as a perfectly circular pool of intense living light. All around the rim of the milky pool were a complex variety of sexual rites, a metaphor for all social interaction. Translucent Hindu deities swooped over the group taking the excessive energy of the shimmering pool and passing through the group as ecstasy and pain. I saw that the reason we were all brought together was to provide a psychic energy feast for the Gods and Goddesses. I saw my heart as the axis of karmic, earthly, and universal energies, transected by and uniting the polarities of male/female, birth/death, good/evil, and love/hate. To maintain a balance of forces we all fed both Deities and Demons.

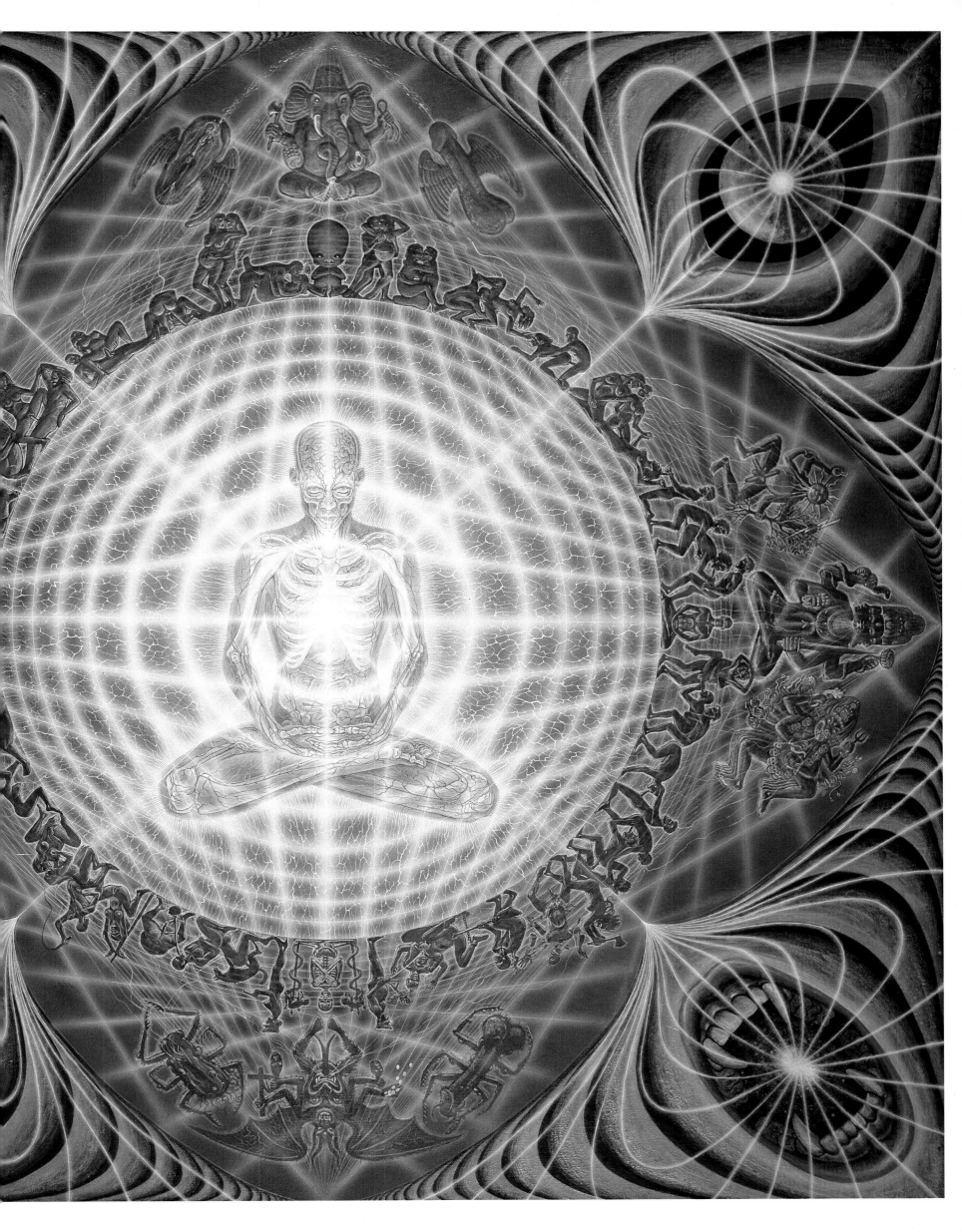

THEOLOGUE
1986, ACRYLIC ON LINEN
60 × 180 IN.

During deep meditation, I entered a state where all energy systems in my body were completely aligned and flowing; it was in this state that I envisioned Theologue—The Union of Human and Divine Consciousness Weaving the Fabric of Space and Time in Which the Self and Its Surroundings Are Embedded. I was wearing a Mindfold which allowed me to stare into total darkness. I stared into an infinite regress of electric perspective grids that radiated from my brain/mind and led

to the horizon. A mystic fire engulfed me. Across the horizon all I could see were perspective lines going into deep space. I was seeing both the perceptual grid of my mind on which space and time are woven, and the universal mind which was both the source and the weaving loom. At this moment, faintly, Himalayan mountains appeared. Transparent, but present, they formed a vast and beautiful panorama and then disappeared back into the grid.

NOTES: IN THE EYE OF THE ARTIST

1. The Great Chain is often said to consist of five, seven, or even more levels of being and knowing; my own model presents over two-dozen carefully defined ontological levels. (See Wilber, K., *The Atman Project;* Wilber, Engler, and Brown, *Transformations of Consciousness.*) For the purposes of this foreword, the simple three-level division will suffice, but it should be kept in mind that a theory of art based on the Great Chain of Being can be much more precise than three levels.

2–6. Quotations are from Roger Lipsey's *An Art of Our Own* (Boston: Shambhala Publications, 1988), which I strongly recommend as the best introduction to the subject of art and the spirit. See also, *The Spiritual In Art—Abstract Art 1890–1985* (New York: Abbeville Press, 1986).

7. Robert Clements, editor, *Michelangelo: A Self-Portrait* (Englewood Cliffs, New Jersey: Prentice-Hall, Inc., 1963), 67.

8–9. Anthony Blunt, *The Art of William Blake* (New York: Columbia University Press, 1959), 23.

10. Jean Delville, *The New Mission of Art: A Study of Idealism in Art* (London: Francis Colmer, 1910).

11–16. Lipsey, *An Art of Our Own* (see notes 2-6).

NOTES: THROUGH DARKNESS TO LIGHT

1. For a thorough historical investigation of the relationship between performance art and shamanism, see Thomas McEvilley's "Art in the Dark," *Artforum,* Summer, 1983, or in *Apocalypse Culture,* Amok Press, 1987.

2. Carl Jung, *Memories, Dreams, Reflections* (New York: Vintage Books, 1963), 346.

3. Buddaghosa, *Visuddimagga, The Path of Purification* (Boulder, Colorado: Shambhala Publications, 1976).

NOTES: THE SACRED MIRRORS

1. Pahnke, Walter N. and Richards, William A., "Implications of LSD and Experimental Mysticism," *Journal of Religion and Health,* No. 5, 1966, 175–208.

2. See Green, Elmer and Alyce, *Beyond Biofeedback* (New York: Dell Publishing, 1977), 306–311; Rama, Swami, *First Step Toward Advanced Meditation,* audio cassette, Himalayan International Institute, RDI, Honesdale, Pennsylvania 18431, 1978; Kluver, Heinrich, *Mescal and the Mechanism of Hallucinations* (Chicago: University of Chicago Press, 1966); Crookall, Robert, *The Study and Practice of Astral Projection* (Secaucus, New Jersey: Citadel Press, 1976), 119, 122, 127, 192; Moody, Raymond A. Jr., M.D., *Life After Life* (New York: Bantam Books, 1976), 30–34.

3. See Grant, J. C. Boileau, *Grant's Atlas of Anatomy,* 6th Edition (Baltimore: Williams & Wilkins Co., 1972); Montgomery, Royce L., Ph.D., *Basic Anatomy for the Allied Health Professions* (Baltimore-Munich: Urban & Schwarzenberg, 1981); Netter, Frank, M.D., *The Ciba Collection of Medical Illustrations,* Vol. 1–7, (Summit, NJ: Ciba Pharmaceutical Co., 1972–79); Schaeffer, J. Parsons, M.D., editor, *Morris' Human Anatomy,* 10th Edition (Philadelphia: Blakiston Co., 1947), Sobotta and Figge, *Atlas of Human Anatomy,* Vol. 1–3 (Baltimore-Munich: Urban & Schwarzenberg, 1980); and Yokochi, *Color Atlas of Anatomy* (New York: Igaku—Shein Medical Publishers, 1983).

4. See Boadella, David, editor, "Energy and Character Magazine," *Journal of Bio-Energetic Research,* Abbotsbury, England, January 1976; Bukay, Michael and Buletza, George F., Jr. Ph.D., "Varieties of Aura Perception," (Oceanside, CA: *The Rosicrucian Digest,* January 1979, 17–21); Burr, Harold Saxton, *Blueprint for Immortality: The Electric Patterns of Life* (London: Neville Spearman, 1972); Hunt, V. V., Massey, W. W., Weinberg, R., Bruyere, R., Hahn, P.M., *Project Report: Study of Structural Integration from Neuromuscular, Energy Field & Emotional Approaches,* (Boulder, Colorado: Rolf Institute of Structural Integration, 1977); Kilner, Walter J., *The Human Aura* (New Hyde Park, New York: University Books, 1977); Leadbeater, C. W., *The Chakras* (Wheaton, Illinois: Theosophical Publishing House, 1974); Leadbeater, C. W., *Man Visible and Invisible* (Wheaton, Illinois: Theosophical Publishing House, 1975); Meek, George, editor, *Healers & the Healing Process* (Wheaton, Illinois: Theosophical Publishing House, 1980); Motoyama, Hiroshi, *Science and the Evolution of Consciousness* (Brookline, Massachusetts: Autumn Press, 1980); Ohsawa, George, *Acupuncture and the Philosophy of the Far East* (Boston: Tao Publications, 1973); Reich, Wilhelm, "Discovery of the Orgone" (New York: *International Journal of Sex Economy and Orgone Research,* Vol 1, 1942); Becker, Robert O. and Seldon, Gary, *The Body Electric, Electromagnetism and the Foundation of Life* (New York: William Morrow, 1985).

5. See Dhargyey, Geshe Ngawang, *Kalachakra Initiation* (Madison, Wisconsin: Deer Park, 1981); Govinda, Lama Anagarika, *Foundations of Tibetan Mysticism* (New York: Samuel Weiser, 1977); Trungpa, Chogyam, Rinpoche, *Visual Dharma: The Buddhist Art of Tibet* (Berkeley & London: Shambhala Press, 1975); Reynolds, John M., translator, *Self-Liberation Through Seeing with Naked Awareness* (Barrytown, NY: Station Hill Press, 1989). Foreword by Namkhai Norbu.

6. See Pagels, Elaine, *The Gnostic Gospels* (New York: Vintage Books, 1981), 70.